WARRINGTON
IN
50
BUILDINGS

JANICE HAYES

AMBERLEY

First published 2016

Amberley Publishing, The Hill, Stroud
Gloucestershire GL5 4EP

www.amberley-books.com

British Library Cataloguing in Publication Data.
A catalogue record for this book is available from the British Library.

ISBN 978 1 4456 5916 9 (print)
ISBN 978 1 4456 5917 6 (ebook)

Origination by Amberley Publishing.
Printed in Great Britain.

Contents

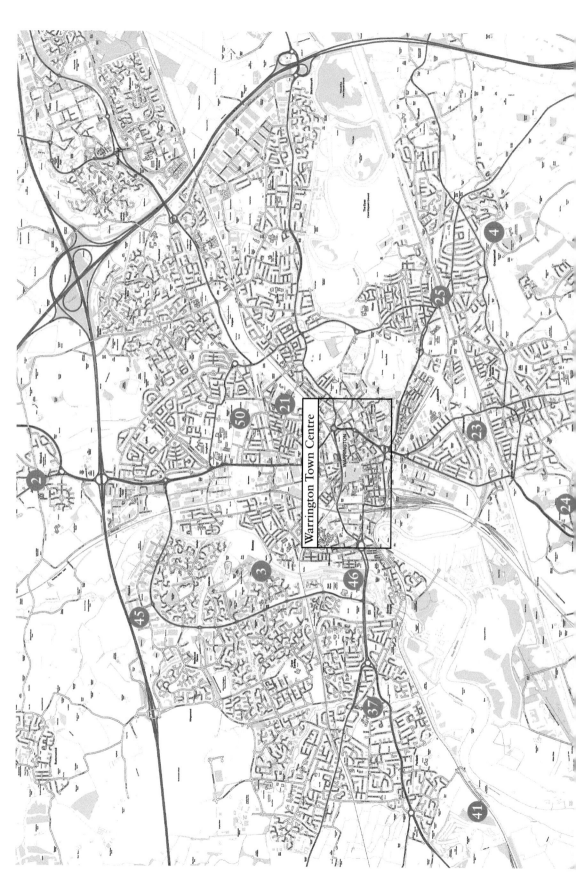

Warrington Town Centre

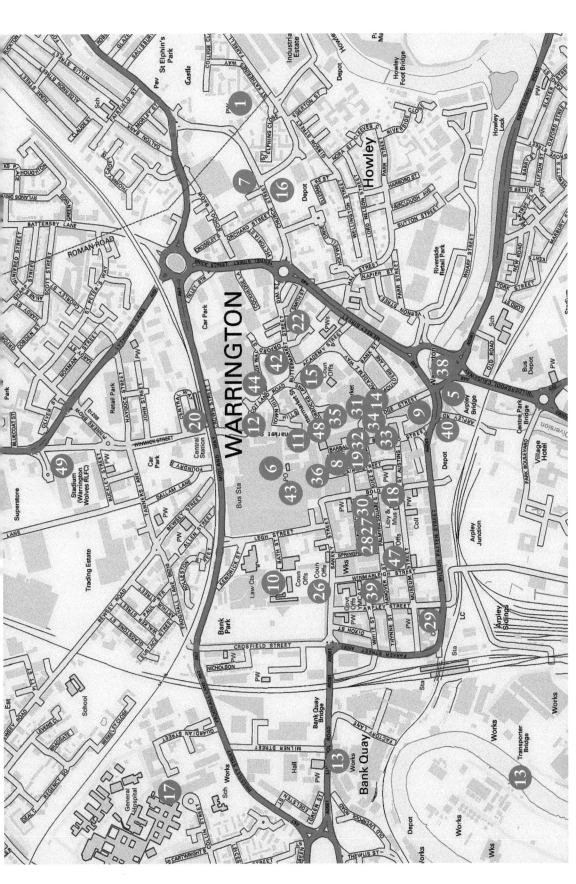

Preface

Describing Warrington in a mere fifty buildings is an almost impossible task. The town has changed beyond recognition since the 1970s with the addition of former Lancashire and Cheshire villages after local government reorganisation and the creation of completely new districts in the new town era. Each of the sixty or so areas that make up present-day Warrington might justifiably nominate at least a dozen sites of importance to them. Only half of the fifty-two buildings listed as being of special architectural and historical interest in 1947 are still available for inclusion and not everyone would appreciate the relevance of some of the survivors to twenty-first-century life. The pace of change is accelerating and the current redevelopment of the Bridge Street area has swept away buildings under forty years old, almost before their value to the town's cultural heritage could be assessed, while other historic buildings decay almost unseen.

Local historians and conservationists value the built landscape for its historical importance and contribution to major architectural movements. The public at large are less concerned with these weighty matters but have an affection for places where they spend their leisure time, meet friends, shop or work – or even an unassuming building that just seems like a familiar face in the daily landscape of their life.

Difficult choices had to be made by the author and so this volume is weighted to the traditional Borough of Warrington prior to 1974. It features all aspects of the built landscape with particular links to the town's cultural heritage, even if some are not of acclaimed architectural merit, and some personal favourites that insisted on being included.

Those wishing to delve more deeply into the town's architectural heritage and make their own selection may wish to consult:

The Buildings of England: Lancashire, Liverpool and the South-West, Richard Pollard and Nikolaus Pevsner (2006).

Harry Well's detailed local booklets, especially his *Walking Into Warrington's Past* series.

Warrington's local history resources held at Warrington Museum.

Warrington's built landscape, which is all around you and offers tantalising clues to your heritage.

The varied architecture of Warrington's rapidly changing skyline.

Introduction

Warrington is a new town with a long history and there are clues to its past in its built architecture. Fortunately there are many images of Warrington that show how it has changed over the centuries and provide glimpses of surviving buildings, even amid a largely changed townscape.

The first surviving image of Warrington dates from 1580 and shows that there were three dominant buildings in the town: Warrington's important bridge and the two churches of the friary in Bridge Street to the west and the parish church to the east. Clustered around these, off the main streets, were small black-and-white half-timbered houses, some of which would survive for another three centuries.

Donbavand's painting of Warrington in 1772 reveals how the town's architecture was beginning to change. His view looks towards the town centre from the Cheshire side of the river. High in the centre is the tower on Holy Trinity Church at Market Gate. On the extreme left are the cones of the glass houses at Bank Quay. Just to the right of those is Bank Hall, the home of Thomas Patten (which became Warrington Town Hall). Flat-bottomed barges are sailing up the river from Liverpool to dock at the new port of Bank Quay to sail on to Warrington Bridge (extreme right).

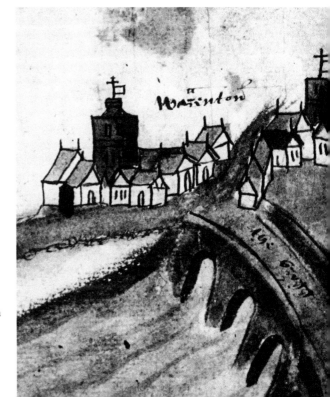

Warrington in the 1580s showing the bridge in the foreground and the parish church on the right.

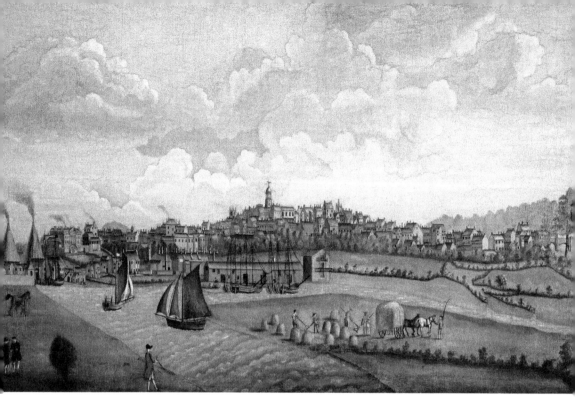

Donbavand's view of Warrington in 1772.

A number of contemporary visitors to the town commented that although the town's main streets were narrow and crowded new brick buildings were appearing, suggesting the town was becoming more prosperous.

Even by the time of Hall's 1826 map, the town's buildings barely extended beyond Warrington's four main streets into the open fields beyond; Warrington was still largely known as a market town. By the 1840s, Warrington Market Place was a focus for country people trading grain, vegetables and meat at the weekly markets and also livestock at the fortnightly Wednesday fairs. Dairy produce, such as butter and cheese, was also on offer at the temporary trestle tables in front of the Barley Mow Inn.

However, industry was already encroaching along the riverside as new factory chimneys appeared at Ryland's wireworks in Church Street, while cotton mills sent steam billowing into the sky. Although Warrington had a new three-arched stone bridge by the late 1830s, the town was clearly changing.

The town's population was growing rapidly as the move from the country to new workplaces at the heart of the town began. Annual festivals, such as Warrington Regatta, continued and crowds turned out each July to watch the vessels sailing past the new St James's Church on Wilderspool Causeway towards the tall cotton factories, which were beginning to dwarf established landmarks such as the tower of Holy Trinity Church. Soon the river was too polluted for the race to continue and the green spaces along its banks began to disappear.

In the 1870s, the town's population increased by 37 per cent and most of these new workers wanted to live close to their place of work. Soon the Bridge Street tradesmen saw lodging houses and insanitary back-to-back housing appearing in the courtyard behind their shops. As the century progressed, wealthier Warringtonians moved away from the

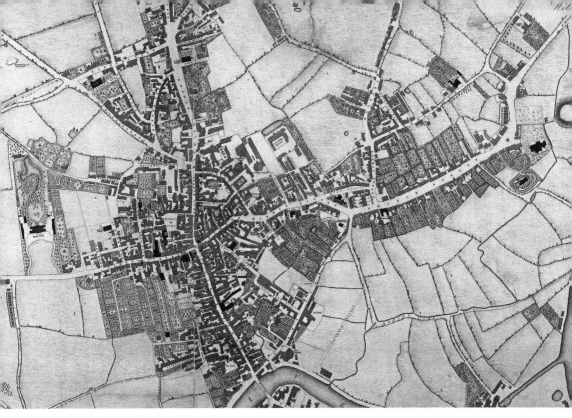

Above: Hall's map of 1826 shows the open fields surrounding the main streets.

Below: A busy scene in Warrington's early nineteenth-century Market Place.

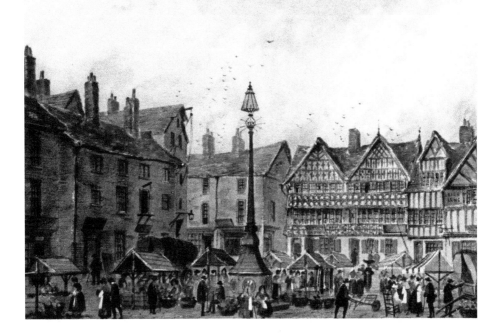

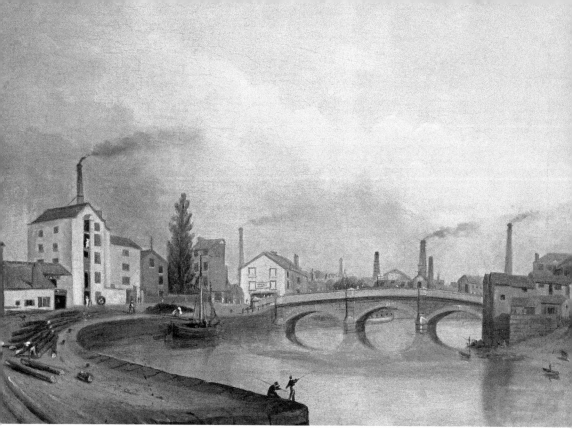

Above: Factory chimneys appear near Warrington's Victoria Bridge, *c.* 1840.

Below: Warrington's annual regatta sails to the town centre in the early 1840s.

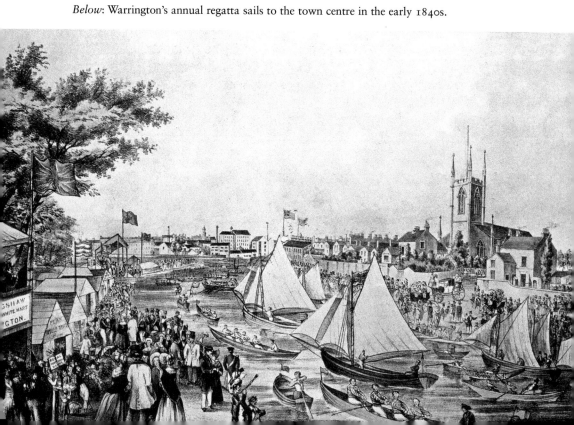

town into new suburbs south of the new Manchester Ship Canal, where streets of new villas sprang up. Even on the outskirts of the town centre, improved terraced housing for better-paid workers was available, distinguished by the new glazed brickwork, bay windows and even small front gardens. For the Cockhedge factory workers and the iron and steel workers of Whitecross, living alongside the factory was still a necessity. Pollution from these works hung over the town like a pall and soot turned the fine old stonework of Warrington's buildings a depressing black.

At the turn of the twentieth century, a regeneration of Bridge Street and Market Gate began. New public buildings appeared, providing opportunities for a small group of local architects, whose work can still be traced today. The Second World War brought an end to 1930s' proposals to regenerate the Old Market Area, which survived until the creation of Golden Square in the 1980s. This was part of a planned remodelling of Warrington after its designation as a new town in 1968, which saw many of the town's old buildings disappear in the long-running conflict between progress and conservation.

Early twenty-first-century Warrington is a prosperous town with ambitious regeneration plans taking shape. Contemporary architecture is appearing in the historic town centre but familiar landmarks like the parish church still have a prominent place on the skyline.

Armitage & Rigby's Cockhedge cotton mill dominates this 1930s' view.

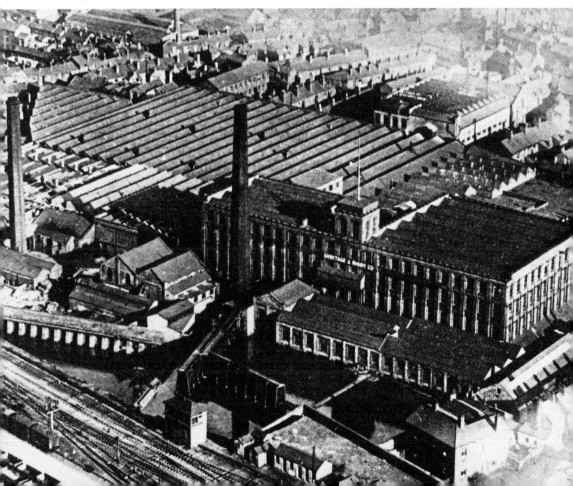

Above: The first phase of Golden Square takes shape in the early 1980s.

Below: The parish church spire is still the focal point of the town.

The 50 Buildings

1. Warrington Parish Church

The spire of Warrington's parish church is the most visible feature of Warrington's skyline in the surrounding landscape, but today the building itself is tucked away on the fringe of the town centre. In this secular age, most Warringtonians are more likely to visit the supermarket opposite than be part of its congregation but to step inside is to walk through the town's history.

Although a church dedicated to St Elphin is recorded in the Domesday Book of 1086, there had probably been a place of worship here from the seventh century. The site of the parish church was a natural centre for a settlement, on raised ground overlooking the ancient ford over the Mersey. By the early thirteenth century it stood at the heart of the medieval village of Warrington and adjoined the castle of the Boteler family, who were lords of the manor of Warrington. The parish was the centre of local government and church festivals were an important part of people's lives.

In the early twelfth century, the church was rebuilt in stone and it was remodelled in the fourteenth century as the town grew in prosperity. The crypt and its staircase, along with the main chancel and parts of the transept, survived the drastic remodelling of the Victorian period. During the sixteenth-century Reformation, the church was transformed from a Catholic to an Anglican church with non-attendance at Sunday services punishable by a fine. During the English Civil War, the church was used as a Royalist stronghold during the attack from the Parliamentarian army in the siege of 1643. Cannonball marks can still be seen on the exterior of the chancel and a new tower was needed as part of the repairs. During the eighteenth century, wooden galleries were added to cater for the town's growing population, but many of the wealthier families lived at the opposite side of the town and funded the building of a town centre church as its rival.

The roof of the fourteenth-century crypt.

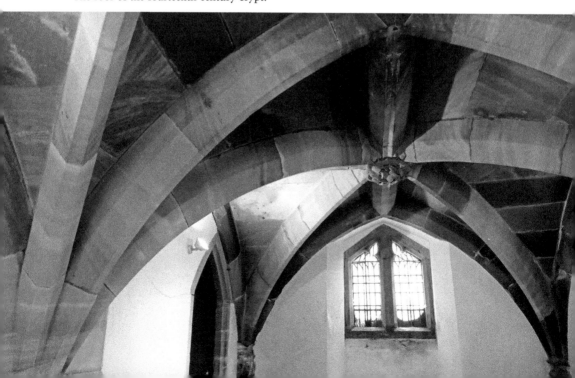

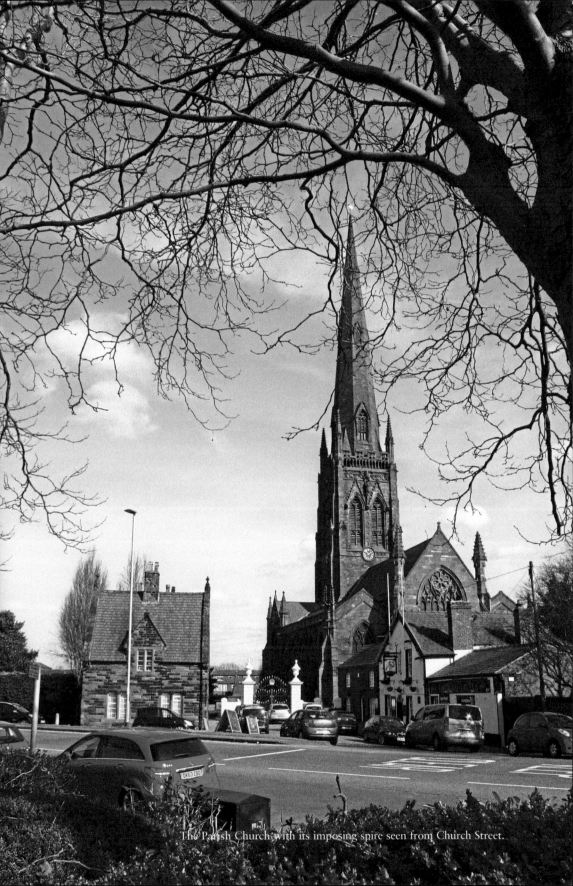

The Parish Church with its imposing spire seen from Church Street.

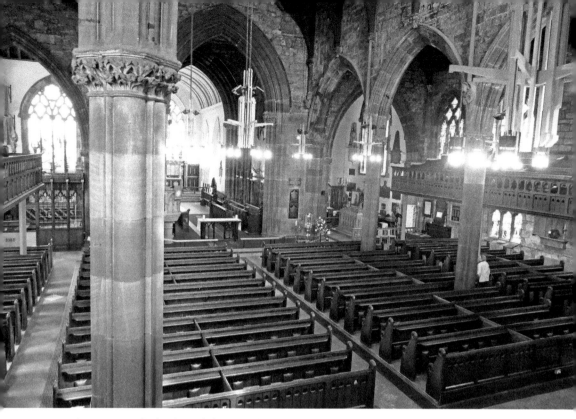

A view towards the chancel showing the impressive interior.

When Revd William Quekett arrived in 1854 to become Rector of Warrington, he was dismayed to discover that the tower and other parts of the building were in danger of collapse. He made it his mission to restore the church but architects Frederick and Horace Francis largely rebuilt it in the medieval style, retaining some complementary features but removing the eighteenth-century interventions. Quekett needed his church to be a visible symbol of Christianity, and for that he needed a spire. Quekett knew the value of a good slogan and launched an appeal for 'a guinea for a golden cock'. His fundraising technique was successful and the spire's weathercock was duly gilded with sovereigns. Warrington's parish church spire soared over the landscape at a height of about 281 feet (85.65 metres), making it the third-highest parish church spire in England.

The parish church interior still enshrines much of Warrington's history through its memorials and stained-glass windows. An effigy of Lord Winmarleigh, great-grandson of the builder of Warrington's town hall, can be seen in St Anne's chapel to the right of the chancel. The former Boteler chapel to the left of the chancel was remodelled as the regimental chapel of the South Lancashire Regiment but still contains the alabaster tomb of Sir John Boteler, a fitting reminder of the church's founders.

2. Winwick Church

Rivalling Warrington's parish church in antiquity is St Oswald's Church at Winwick, which is now at the northern edge of Warrington, but for most of its history has been outside the old borough of Warrington. Unlike St Elphin, the origins of the dedication to St Oswald are

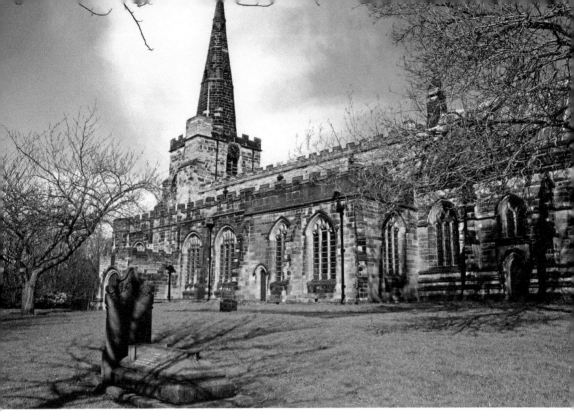

Above: St Oswald's, Winwick, raised above the neighbouring road.

Below: A statue of St Anthony stands next to the famous Winwick pig.

much clearer but possibly more ancient. The Winwick area had settlement dating back to the Bronze Age period and the raised platform on which the church sits would have been an ideal position to keep watch over the surrounding landscape and the nearby Roman road. Tradition associates nearby Ashton-in-Makerfield with the site of the death of Oswald, Christian King of Northumbria, at the Battle of Maserfeld in AD 642, and the church is dedicated to this saint. It is likely that there was a pre-Christian sacred place nearby and it was common for Christian churches to take over an earlier holy site.

However, according to an ancient story, the exact spot where the church was to be built was decided by a pig. As the foundation stones were laid, a pig was seen running around the building site, and was said to have picked up a stone in its mouth and dropped it on the spot where the saintly king had fallen. The builders took this as a sign and abandoned the earlier site in favour of the place where the stone had dropped.

St Oswald's was heavily restored in 1846–49 by leading Anglo-Catholic architect A. W. N. Pugin, who is better known for rebuilding the Palace of Westminster in his trademark Gothic Revival style. Fortunately for Rector Hornby, Winwick was one of the richest parishes in the country and so he could afford to employ this young architect, who he considered to be the greatest artist in the country. The renovation saw a mixture of Pugin's characteristic medieval-influenced stained glass, decorative tiles and ornate reredos and altar combined with restored medieval features. The earlier history of the church survive in the Gerard and Legh chapels and a rare sculpture that is part of an Anglo-Saxon or possibly Viking cross.

3. Bewsey Old Hall

Bewsey Old Hall has been home to some of Warrington's most important families and even visited by royalty. In the late thirteenth century, the Botelers built a single-storey wooden hall on the site. This powerful family were lords of the manor of Warrington from the 1260s to 1586. They moved from a wooden castle near the parish church to their lands in the royal forest of Burtonwood. As they spoke Norman French, they called their new home '*un Beau See*', or 'Beautiful Place', and governed the town from there.

In 1495, Henry VII spent the night at the hall on a visit to Lancashire. In the late sixteenth century, the Botelers started to alter the house, possibly rebuilding in brick. On the death of Edward Boteler in 1586, Bewsey passed to Robert Dudley, Elizabeth I's favourite, to pay off Edward's gambling debts. A 1587 survey of Bewsey manor undertaken for Dudley gives us a description of the hall:

> The house is surrounded with a fair moat over which is a strong drawbridge. The house is very large but one half of it being of very old building is decayed. That part is the hall, the old buttery, pantry, cellar, kitchen, dairy and brew house. The other half of the house is of new building and has one great chamber (room) four other chambers, a kitchen, a buttery. Three other chambers and a parlour of the old building are in good repair. There is also a chapel but much decayed and a garden.

Robert Dudley sold off the Boteler lands and Thomas Ireland, a wealthy lawyer from Childwall, bought Bewsey and the manor of Warrington, moving in by 1602. In 1617,

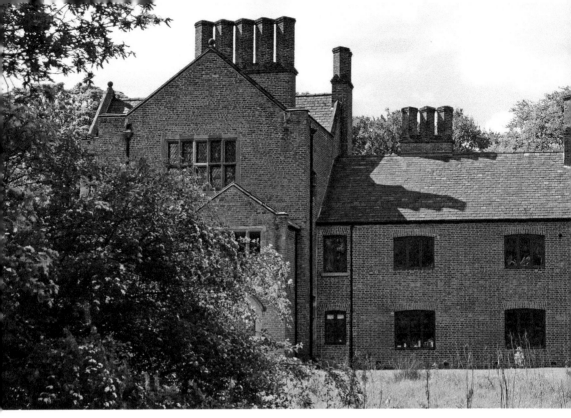

Above: A glimpse of the restored Bewsey Old Hall through the surrounding woodland.

Below: Bewsey viewed from the canal around 1830 with the Georgian wing (right).

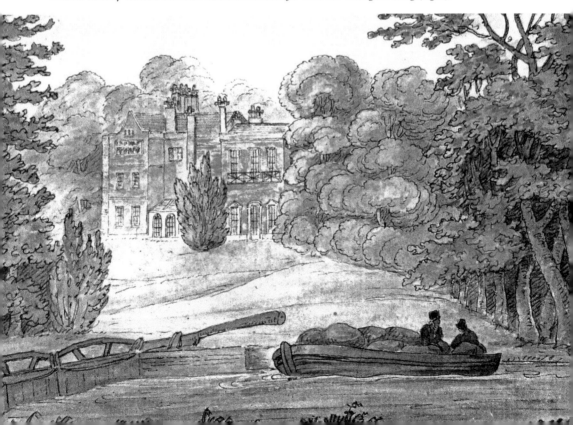

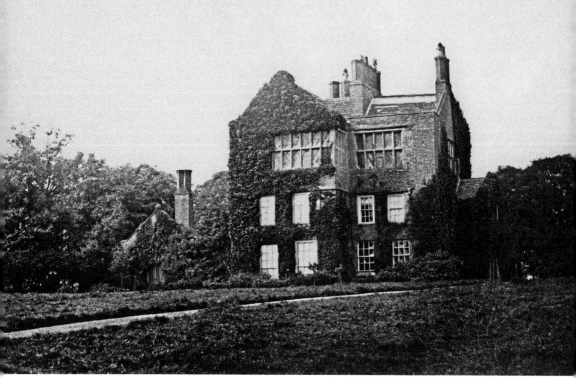

Bewsey Old Hall in the mid-1850s without the Georgian wing.

James I stayed at Bewsey and knighted its new owner, Sir Thomas Ireland. The Ireland family owned Bewsey until 1675 but Sir Thomas's son was forced to sell off the manor of Warrington in 1625 to pay his debts. In 1675, the Atherton family inherited Bewsey and in the mid-eighteenth century added a new wing, where it was rumoured that Bonnie Prince Charlie stayed overnight.

In 1797, the house passed by marriage to the Lilford family. They demolished the eighteenth-century wing, built a new hall in the grounds in the 1860s and turned the Old Hall into two farmhouses, which were let out to tenants. Bewsey Old Hall's decline had begun. In 1926, Lord Lilford sold much of the old Bewsey Park to Warrington Borough Council for the building of a new estate of council houses. In 1974, Warrington New Town Development Corporation bought the remainder of the estate from Lord Lilford, and more recently what remained of the building was developed as private apartments.

4. St Wilfrid's Church, Grappenhall

At the southern end of present-day Warrington lies the village of Grappenhall, the former stronghold of the Boydell family, the Botelers' bitter rivals for supremacy in the region. At the heart of the village is St Wilfrid's Church, which probably dates from at least the twelfth century, while Grappenhall itself is mentioned in the Domesday Book of 1086. Although much modified over the centuries, the church contains a very early carved font, a parish chest, medieval stained glass and the much-restored sandstone effigy of a knight in the Boydell Chapel.

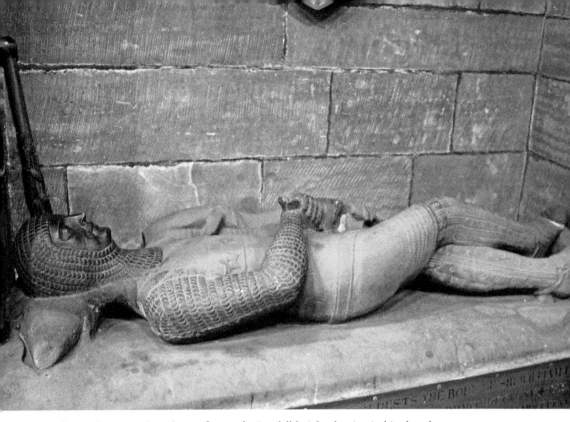

Above: The restored sandstone figure of a Boydell knight sleeping in his chapel.

Below: St Wilfrid's interior shows the splendour of the nineteenth-century remodelling.

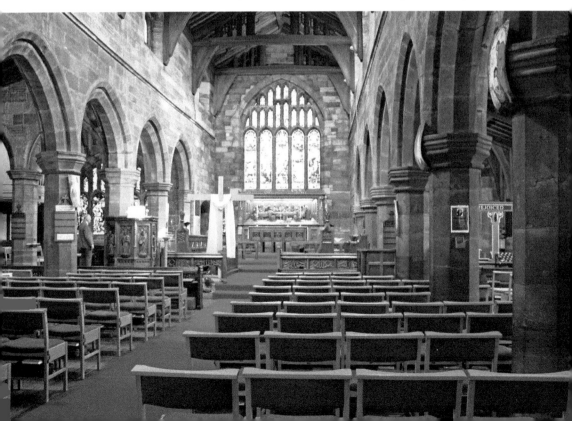

Before the Manchester Ship Canal was built in the late nineteenth century, Grappenhall was linked to Latchford by an ancient crossing place over the River Mersey. In the early thirteenth century, the Earl of Chester allowed the Boydell family to levy tolls on fords and ferries across the Mersey between Runcorn and Thelwall. In 1277, William Boteler gained a charter to confirm that he could hold markets in Warrington, but anyone travelling to it from the south would have to pay the Boydells to cross the river. So the Botelers built a rival river crossing at Warrington Bridge and collected the tolls there. The Boydells were angry because they lost money and blocked access to the roads leading to Warrington Bridge. The quarrel grew heated, but in the end the more powerful Botelers triumphed and Grappenhall remained a smaller settlement.

St Wilfrid's was heavily restored in the mid-nineteenth century under leading Lancashire architects Paley and Austin when medieval architecture was again in fashion. It is said that a stone carving on the tower might have inspired Lewis Carroll's Cheshire Cat as his father, Revd Dodgson, often visited the church.

5. Warrington Bridge

Location, location, location has been the key to Warrington's prosperity throughout its history. From earliest times people came to Warrington to cross over the River Mersey – first on foot by the ancient ford at Latchford and later by Warrington Bridge. The Botelers had funded an early wooden structure there by 1285 to bring traffic to their Church Street market, but gradually trade moved to a new street leading to the bridge, which became known as Bridge Street. Soon the market moved to the north of the bridge to the spot where Bridge Street met the east–west route through the town or Market Gate.

The early wooden bridge gave way to a sturdier stone bridge, which collapsed in the 1450s, but eventually the third bridge was constructed, paid for by Thomas Stanley, Earl of Derby. This substantial three-arch stone bridge survived until the early nineteenth century when it became an obstacle to the increased river traffic. An experimental wooden bridge proved a short-lived successor and in 1837, a sturdy stone bridge was opened and named after the new queen, Victoria.

By 1900, the 20-foot-wide Victoria Bridge had proved inadequate for the increasing volume of road traffic and an 85-foot-wide replacement was built. 'There is not a single improvement in Warrington which is more urgently needed … and everybody has been crying out for a new bridge for years,' declared Councillor Bennett, who had masterminded the project.

In 1911, work finally began on the construction of a new reinforced concrete bridge designed by Warrington-born J. J. Webster. The first half was opened on 7 July 1913 by George V and in April 1915, the new bridge was revealed in all its glory in the midst of the First World War. Bennett could never have foreseen the increased volume of traffic in the rest of the century and sadly Webster's bridge also proved inadequate. Despite the construction of the motorways bypassing the town and the construction of a second river crossing at Bridge Foot in the 1990s, Warrington Bridge is still a traffic bottleneck today as Warrington continues to play a vital role in the transport network.

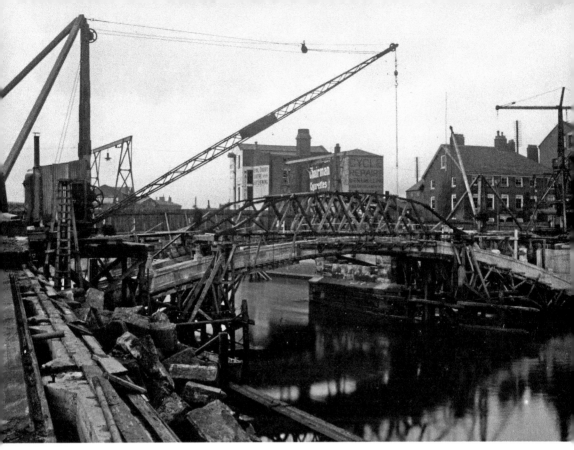

Above: Webster's reinforced concrete bridge under construction.

Below: The graceful lines of Webster's Warrington Bridge, completed in 1915.

6. The Barley Mow

The Barley Mow is the oldest building in Warrington's town centre, dating back to the 1560s during the reign of Elizabeth I. Although it has been considerably altered over the years, it is typical of many of the half-timbered buildings with quatrefoil patterning, which could be found in many Cheshire and south Lancashire towns of the period. It was on a grander scale than the thatched cottages that once lined Church Street and its location in Warrington Market Place suggests it was probably the home of a wealthier merchant. It featured in an engraving of the Old Market Place of the 1840s but by then it had become the Barley Mow Inn with J. Gerrard as the landlord. In the local dialect, the pub was traditionally pronounced to rhyme with cow and the connection with harvest time was appropriate for its link to the old corn market nearby.

As the town prospered in the eighteenth century, many new brick buildings were built in the town centre, including the taller building to its left, which became the offices of William Beamont, Warrington's first mayor. By the early 1900s, minor alterations had been made to the Barley Mow's facade and the small oval window appeared at ground level. By then a new general market had been built behind the pub and a small alleyway to the left of the building became the direct link from Market Place.

When the Old Market Place was redeveloped in the early 1980s, the Barley Mow was one of the few original buildings to survive; even its neighbour was rebuilt in the Georgian style. The adjacent alleyway still survives but now leads to a small yard as the general market hall was also demolished.

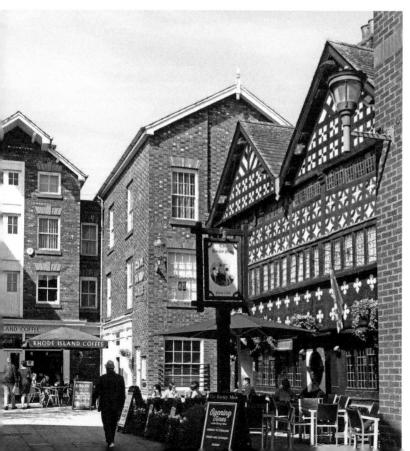

The Barley Mow Inn today with its modern Georgian-style neighbours.

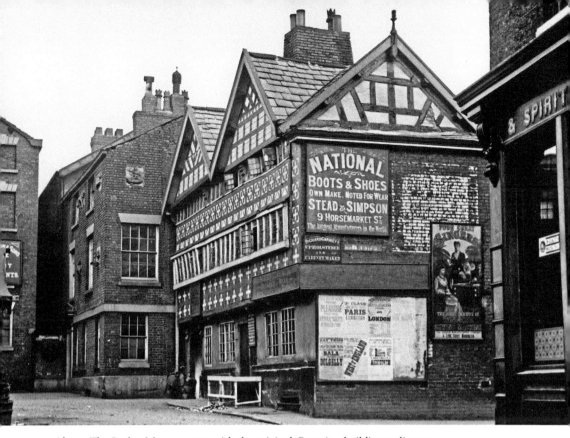

Above: The Barley Mow *c.* 1900 with the original Georgian buildings adjacent.

Below: An oyster-seller sets up his stall outside the Barley Mow, *c.* 1890s.

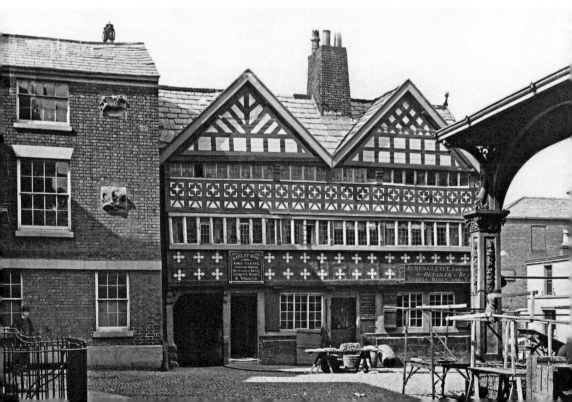

7. The Tudor Cottage, Church Street

In 1887, William Beamont looked back on the changing architecture of the town, remembering the Church Street of his youth as:

> an abundance of quaint, picturesque black and white structures ... of wood and plaster, with patterns in black and white painted on their fronts, with carved weather boards on their eaves, narrow latticed windows and slightly projecting narrow gables.

Today, the building popularly known as the Tudor Cottage is one of only three survivors of a street Beamont would find unrecognisable. Like the Bull's Head and the Marquis of Granby pubs on the opposite side of the street, the Tudor Cottage has been substantially altered since the sixteenth century. The roof is no longer thatched but tiled and the exterior timber work has been in-filled with bricks.

Many people believe that Oliver Cromwell spent the night in the cottage in 1648 during the English Civil War, when he led the Parliamentarian army, who were trying to stop Charles I regaining the throne with Scottish support. On 19 August, the two armies clashed at the Battle of Red Bank near Winwick. The Scots retreated to Warrington where they lost a skirmish with Cromwell's troops at Warrington Bridge and Cromwell actually lodged in the town at a long-demolished building to the left of the Tudor Cottage. In 1899, to commemorate Cromwell's links to the town and the 300th anniversary of his birth, Cllr Frederick Monks presented a statue of Cromwell to the town and this now stands near to Warrington Bridge.

By the early twentieth century, the Tudor Cottage had fallen on hard times and was split into three small shops. In the 1930s, Rylands' Wireworks, which used to stand on the site now occupied by Sainsbury's supermarket, restored the cottage for use as a canteen by their directors and business partners.

The Tudor Cottage, divided into three shops, *c.* 1900s.

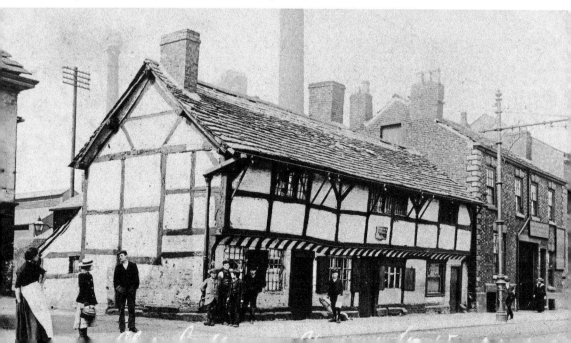

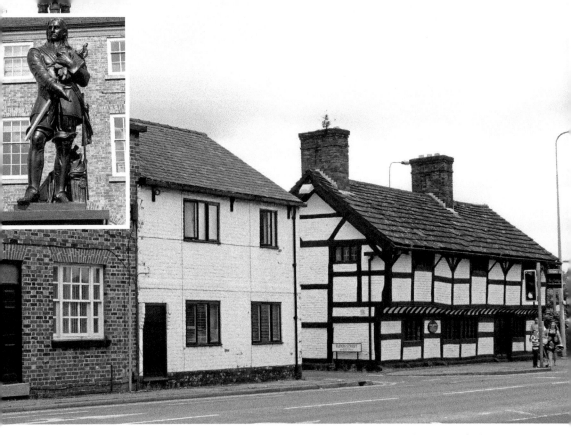

The Tudor Cottage (right) and the site of Cromwell's lodgings (left). *Inset*: The statue of Oliver Cromwell at Bridge Foot.

8. Cairo Street Chapel

By the mid-seventeenth century, many Warringtonians dissented from the teachings and rituals of the Anglican Church. These so-called Nonconformists included Robert Yates, the Rector of Warrington, who was thrown out of his post and briefly set up his own congregation in 1672–73. However, after the Protestant William III came to the throne in 1689, Nonconformists were given the freedom to worship. By 1703, Warrington's Nonconformists built a meeting house on the south side of Sankey Street, and by 1745 a new, larger church was built to cope with the hundreds of people forming its congregation. Several tutors at Warrington Academy worshipped there and are commemorated in memorials inside the church.

In 1846, Philip Pearsall Carpenter accepted the ministry of Cairo Street and soon made his presence felt. He campaigned to improve public health in Warrington, highlighting the unsanitary conditions, and helped to set up the co-operative movement in the town. Like many members of Cairo Street's congregation, he also campaigned against slavery, and in July 1859 he visited the southern states of America, defying the threat of being tarred and feathered, to deliver a lecture against the practice. He was also had an impact on the chapel itself, which was remodelled inside and gained a new entrance into Cairo Street. Today, this is the main entrance of the chapel and its grounds are a peaceful oasis in the heart of the main shopping area.

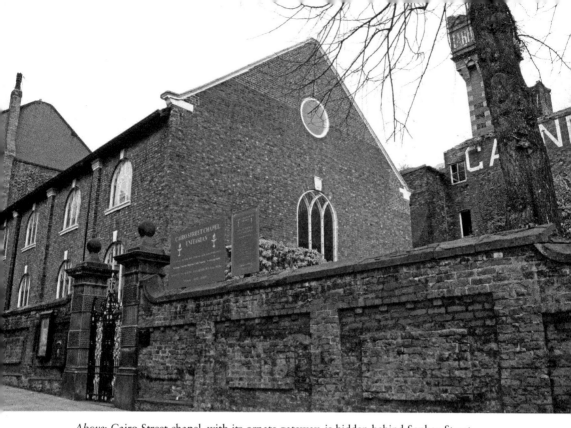

Above: Cairo Street chapel, with its ornate gateway, is hidden behind Sankey Street.

Below: Cairo Street's interior showing some of the monuments to past distinguished members. *Inset*: The Reverend Pearsall Philip Carpenter, minister of Cairo Street chapel from 1846–61.

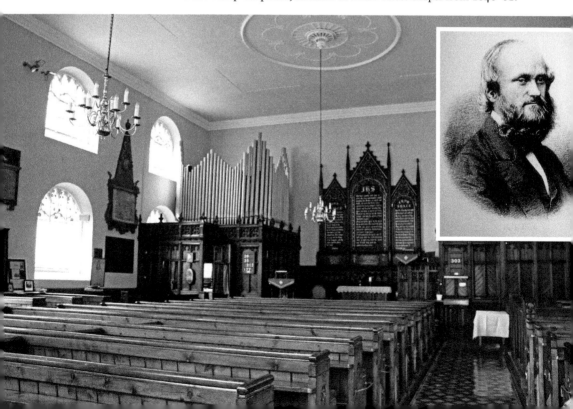

9. Warrington Academy

At the bottom of Bridge Street, close to Bridge Foot, is all that remains of Warrington Academy, which between 1756 and 1786 provided a university education for Nonconformist scholars whose religion prevented them attending Oxford or Cambridge. Revd John Seddon, minister of Cairo Street chapel, was instrumental in founding the academy and the link between the two institutions remained strong. At its height, the quality of the tutors at the academy attracted students from the West Indies and America as well as all parts of England (including John Wedgwood, son of the famous potter).

In 1762, the academy moved to a new purpose-built campus in Academy Place, off Buttermarket Street, and that same year Joseph Priestley took up his post. Priestley was probably the greatest eighteenth-century scientist and began his experiments with oxygen during his time in Warrington. Priestley also pioneered a new curriculum for the academy, based on practical subjects rather than the classics. Other famous tutors included John Holt, one of the leading mathematicians of the period; Revd Gilbert Wakefield, classicist and theologian; Dr Rheinhold Forster, a German naturalist, who sailed with Captain Cook; and Dr Aiken, whose daughter Anna Laetitia Barbauld became a distinguished author.

In 1786, Warrington's early university experiment was at an end and the academy moved to Manchester, eventually becoming Manchester College, Oxford. The old academy building was neglected until the 1890s, when the widening of Bridge Street brought it back to view. By the 1970s, the relentless growth of traffic was already threatening to engulf Bridge Foot and the old academy had become an obstacle to a key road-widening scheme. Demolition was avoided by a remarkable feat of engineering on 22 May 1981 when Pynford's winched the old building to an adjacent vacant spot after slicing it from

The restored old academy in Bridge Street with its original doorway.

Above: The old academy's original site before road-widening, with the ABC cinema behind.

Below: Pynford's winch the old academy to its new site on 22 May 1981.

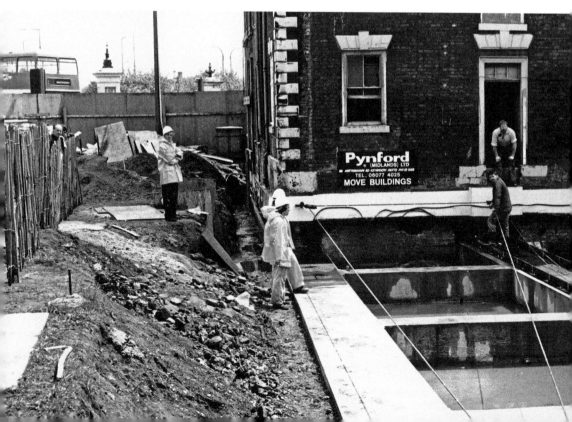

its foundations. The road was widened and then the academy substantially remodelled with very little of the original building remaining. In the early 1980s, it was the short-lived home of Eddie Shah's new national newspaper called *Today* before becoming the new headquarters of the *Warrington Guardian* newspaper until 2016.

10. Warrington Town Hall

Today, Warrington is rightly proud of its fine town hall, which is one of a select number of buildings in the country that are classed as being of the highest importance and given the status of a Grade-I listing. It was not designed as a public building but was a symbol of the social status of Thomas Patten (1690–1772), a wealthy local businessman.

In the late seventeenth century, Patten's father linked Warrington to the developing port of Liverpool by improving the passage of ships up the Mersey to Bank Quay. He traded with towns inland and also set up a copper-smelting works at Warrington's new port. His son continued to prosper but much of his wealth probably came indirectly from the slave trade. Copper bangles from Bank Quay were traded in Africa for slaves, who were sent to the colonies in the West Indies. Here they worked on the sugar plantations, which Patten's works supplied with the large copper pans needed to boil sugar and distil rum.

By 1750, Patten had decided to transform himself from a businessman to a landed gentleman by building a fine mansion in open countryside near to his copper smelting works at Bank Quay. He chose James Gibbs, (1682–1754), one of the finest architects of the day, to build his fine new home known as Bank Hall. Gibbs is best known today for

Gibbs decorative plasterwork in the entrance hall with the 1870s mosaic floor. *Inset*: Thomas Patten (1690–1772) commissioned architect James Gibbs to build Bank Hall.

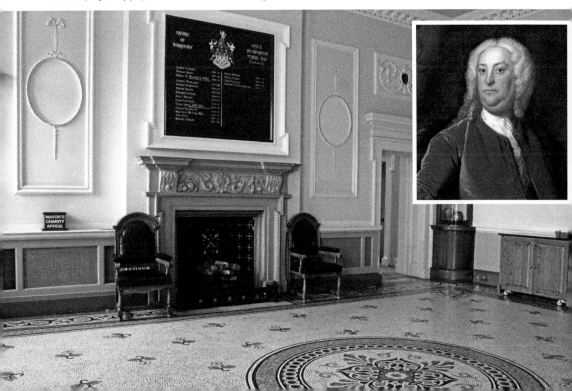

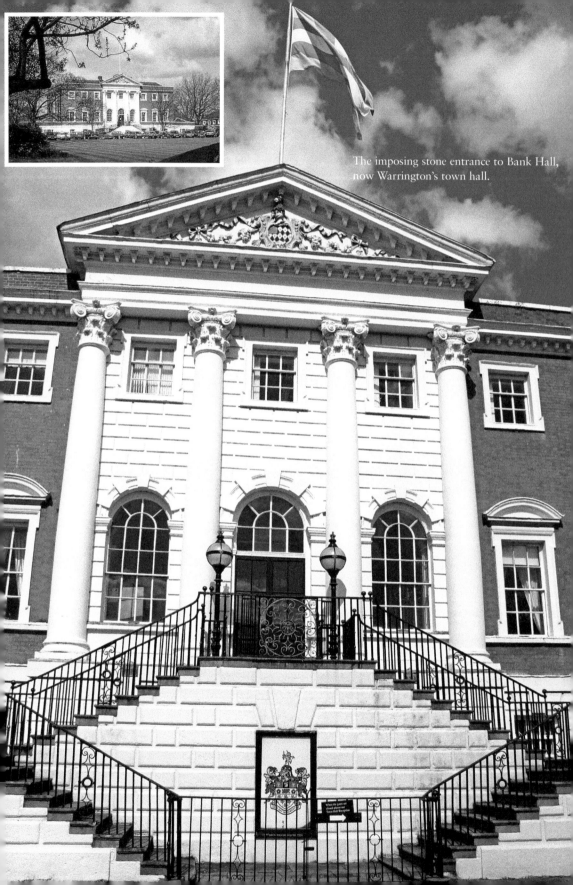

The imposing stone entrance to Bank Hall, now Warrington's town hall.

buildings such as the church of St Martin's-in-the-Field, (Trafalgar Square, London) and the Radcliffe Library in Oxford but he had also produced Italian-style houses for country gentlemen. At Bank Hall, Gibbs used simple red brick for most of the house with more expensive stonework for the grand entrance on the first floor, which was designed to impress visitors. Probably to cut costs, he used waste copper slag from Patten's works as foundation blocks and for the floors and walls of the cellars, using copper for the ground-floor window frames.

A century after Patten's death, Bank Quay had become a busy industrial area and Bank Hall was no longer grand enough for his descendants, who preferred to live in their new mansion at Winmarleigh near Preston. Meanwhile Warrington, which had become a borough in 1847, was in need of a larger town hall and a public park in the centre of the town was also desired. By 1872, Bank Hall and its grounds were purchased for the town at a cost of £9,000 for the building and £13,000 for the grounds with the Crosfield family and the Winmarleighs themselves contributing £12,500 to the cost.

Patten's home has been adapted to its new civic role and, despite some of the alterations made to the building, it is still possible to see much of Gibb's original work, such as the impressive cantilevered staircase and finely moulded plasterwork provided by his team of Italian craftsmen, while the family coat of arms can still be seen over the main doorways.

11. Holy Trinity Church

As Warrington's centre developed away from the medieval village off Church Street, some of the town's leading families felt that the parish church was an inconvenient distance from their homes. In 1709, Peter Legh of Lyme, one of Warrington's leading landowners, set up the small chapel in Sankey Street even though this caused a dispute with the Rector of Warrington, who was jealously guarding his status. However, Holy Trinity's popularity grew and the present larger church was built on the site in 1760. It has long been claimed that it was designed by James Gibbs, who had just completed Bank Hall, and the church is certainly in his style. However, it was common for the pattern books of architects like Gibbs to be used by provincial architects and this may have happened here as the building accounts refer to James Meredith for 'drawing and his attendance on the site'.

Holy Trinity's galleried interior with its box pews has survived largely in its original form and like Bank Hall has a fine Venetian-style window with an arched top. In 1776, wealthy benefactors donated a copy of Andrea del Sarto's *Holy Family*, painted by local artist James Cranke, which was recently relocated to the first floor of the church. An even grander feature was added in 1801, when a flamboyant baroque brass chandelier from the old House of Commons brought much needed light to the expanding congregation. In 1870, Holy Trinity set up its own parish church of St Paul's to cater for Bewsey's growing population. St Paul's fell into disuse and was demolished in the late twentieth century as congregations declined. Holy Trinity has survived and its soot-stained facade was cleaned of grime but few of the shoppers passing to Golden Square are aware of the interesting interior inside this Georgian gem.

The clock in Holy Trinity's tower is noticed every hour as the great bell which once hung in the old court house in Market Place chimes the hour, with two smaller bells signalling each quarter-hour. The octagonal tower is probably the third to grace the church and dates from 1862. However, it actually belongs to the town rather than the church itself.

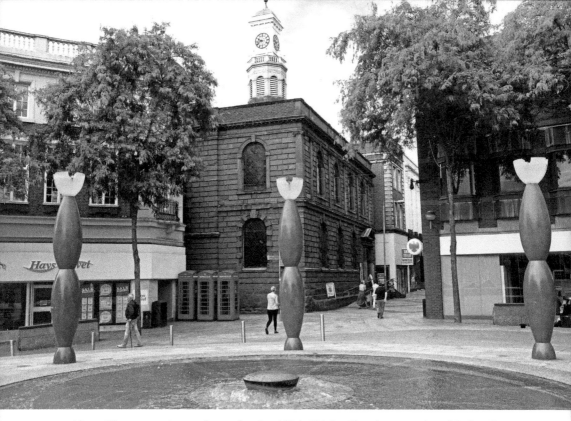

Above: The unassuming sandstone facade of Holy Trinity Church as seen from Market Gate.

Below: Holy Trinity's unexpectedly grand interior with an ornate chandelier, a gallery and stained glass.

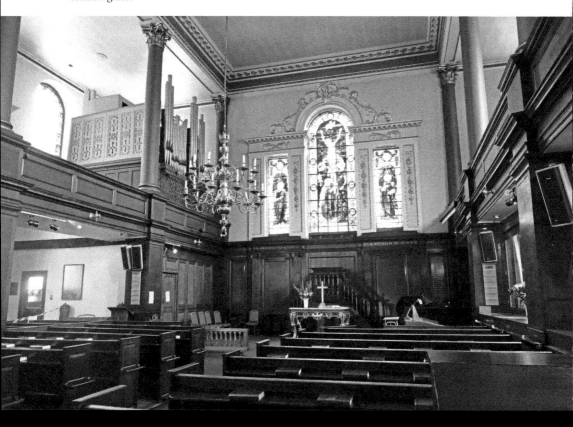

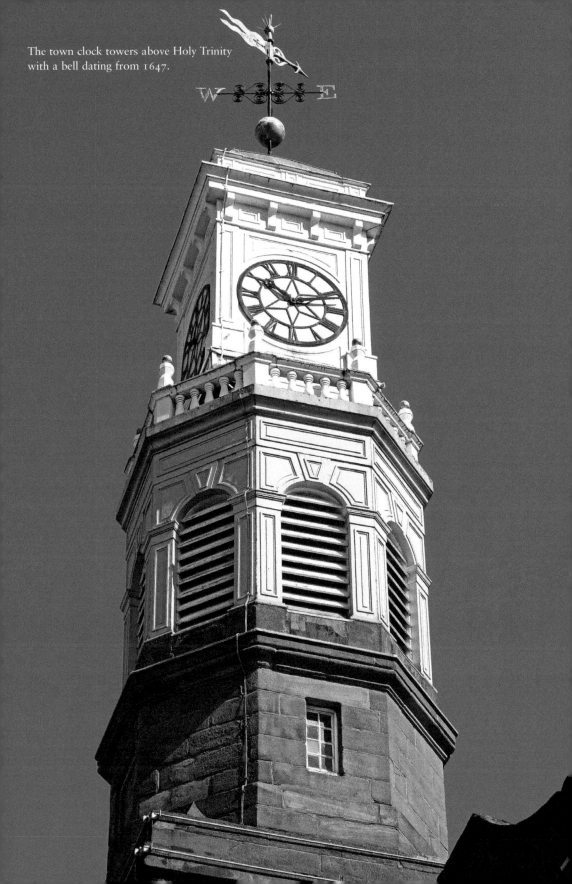

The town clock towers above Holy Trinity
with a bell dating from 1647.

More recently, Holy Trinity has become linked in popular culture to rising local indie band Viola Beach, who were tragically killed with their manager Craig Tarry on their first European tour on 13 February 2016. Media publicity of their career regularly featured an iconic image of Kris Leonard, River Reeves, Tomas Lowe and Jack Dakin and their signature multicoloured umbrella jauntily perched on top of the three telephone boxes outside the church.

12. The Old Bank

Warrington's prosperity grew in the late eighteenth century and this was partly due to a group of wealthy businessmen who invested their money into a bank and loaned capital to others in return for interest. On 25 September 1788, Joseph Parr, his brother-in law Thomas Lyon and Walter Kerfoot, a local solicitor, set up Parr's Bank in Winwick Street, near to the junction with Scotland Road. Lyon was also a partner in Greenall's new brewery and through the Greenalls had links to the Pilkington glassworks at St Helens.

Some of Parr's and Lyon's profits came from their involvement in what they saw as a 'very respectable trade' with the West Indies, which today is widely condemned as the slave trade. Parr and Lyon both had links to the sugar plantations there and invested in a sugar refinery. Many of the investors in their new bank also profited from the trade with some of the Liverpool merchants investing directly in slave ships.

The Old Bank in Horsemarket Street as seen from the new bus station. *Inset*: A decorative plaque on the side of the former bank dates to its rebuilding.

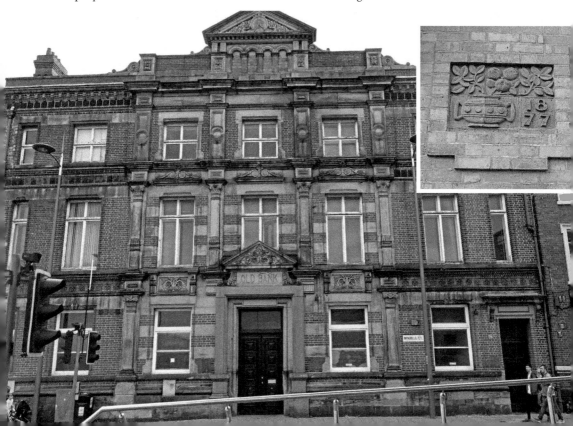

Parr's Bank survived the financial crisis of the early 1800s and by 1843 had a network of forty-three branches. In 1877, the remodelled business built a new Winwick Street headquarters, designed by Thomas Beesley, who emphasised the business' longevity with the inscription of 'Old Bank' above the door. In 1891, the bank became of national importance as part of the London Clearing System. By 1968, Parr's Bank had become part of the National Westminster group by a series of mergers. Soon, its grand banking hall was hidden from view as the banking industry modernised and the branch closed its doors for the last time in 2015.

13. Crosfields

To most Warringtonians, Bank Quay means Crosfields and Crosfields means soap – especially Persil soap powder. Soap and chemical production came to Bank Quay in 1814 when Joseph Crosfield set up his business there. In the 1880s, William Lever set up a rival works nearby before moving to Port Sunlight. Until the early twentieth century, Crosfields remained family-owned and the firm were regarded as good employers. Crosfields provided educational opportunities, good working conditions, sick pay and a range of recreational facilities. These benefits were designed to keep their workers out of the pubs and deter the introduction of unions. Generations of families worked for Crosfields and the firm's influence was especially strong in the immediate Bank Quay community.

Crosfield & Sons offices on Liverpool Road, designed by Albert Warburton.

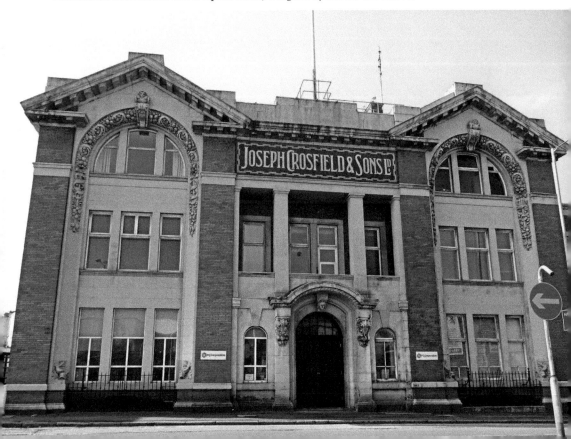

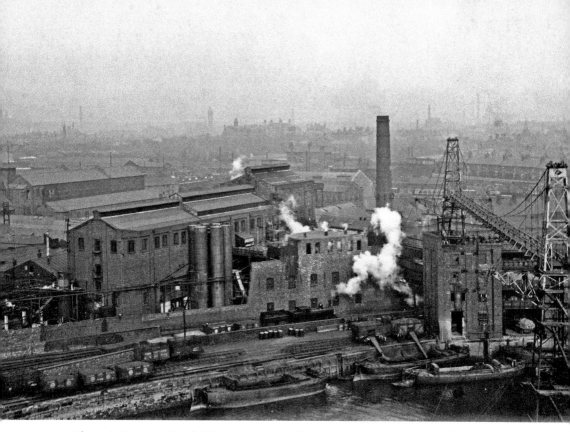

Above: A view over Crosfield's works *c.* 1900 with the original transporter bridge (right).

Below: Crosfield's new Transporter Bridge awaits its centenary in 2016. (Photo © Rob Gresty)

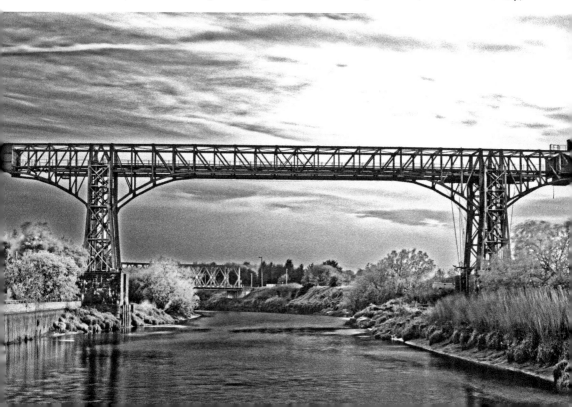

As the works expanded, offices and laboratories were needed and on 12 February 1906 a flamboyant new office block designed by a local architect opened on Liverpool Road. This replaced an earlier block by William & Segar Owen, which was converted into a laboratory.

Besides the manufacture of soap, the Crosfields also refined chemicals, which were needed for their own products but also found a profitable use from some of the by-products of the soap-manufacturing process, such as glycerine. As the business grew, the works were expanded across the river to former Cheshire farmlands as a safer location for the more volatile chemicals. The firm needed a method of transporting goods between the two halves of the site, so in 1906 the first flimsy transporter bridge was built; however, it soon proved inadequate and was converted to carry pipelines.

In 1915, a second and more substantial steel transporter bridge was built by William Arrol & Company to a design by Henry Hunter. Rising above the River Mersey to a height of 76 feet (23 metres) it has a span of 200 feet (61 metres) and is 30 feet (9 metres) wide. Originally designed to carry rail vehicles, it was later converted to carry road vehicles up to 30 tons. The bridge fell into disuse around 1964 but today Crosfield's Transporter Bridge is one of only eight surviving transporter bridges in the world and has listed status.

Just after the First World War, Sir Arthur Crosfield sold the family business to rivals Lever Bros (later Unilever) and latterly the site has been operated by PQ Silicas UK. Today, chemicals for a variety of everyday products are still made at Bank Quay but the traditional soap and soap powder production has ceased.

14. The Lion Hotel

By the mid-eighteenth century, Warrington's location on the national road network ensured that between sixty and seventy stagecoaches ran daily through its main streets. Travellers from nearby towns that did not have direct coach links to London, such as Liverpool, often needed to stay the night in the town to catch their connection. A network of coaching inns sprang up, including the Lion Hotel on Bridge Street, which probably existed in the late 1600s. The current building dates back to 1759 when it was known as the Red Lion, before being renamed the Lion Hotel in 1826. Before the mid-1970s, the Lion had a much longer stable yard, just one of many that housed fresh teams of horses along the coach's route. Until the late nineteenth century, Bridge Street was a narrow, bending highway bustling with traffic. In the heyday of the stagecoach in the 1830s, the Lion Hotel served the same function for London-bound coaches like the pits at a Formula One racetrack do today, as Robert Davies later recalled:

> When the coach drew up, there was a wild scuffle; men unharnessed each one of the smoking team, a man to a horse; another unbuckled the reins, leaving each horse to find its way to the stable yard; four other men were ready with the fresh horses. There was tallow thrust into the grease boxes, often buckets of water were thrown over the wheels, and the reins thrown up to the coachman. In a moment the horses were in a canter, sometimes bucking and jumping … and the coach was quickly out of sight.

Special curved blocks were built into the base of the entrance to ensure the coaches did not collide with the inn's walls and these can still be seen today.

Above: The Lion Hotel in Bridge Street today hides its past as a major coaching inn.

Below right: The entrance to the Lion Yard with the curved blocks to deflect coach wheels (bottom).

Below left: Part of the Lion Yard with the former Assembly Room (top left).

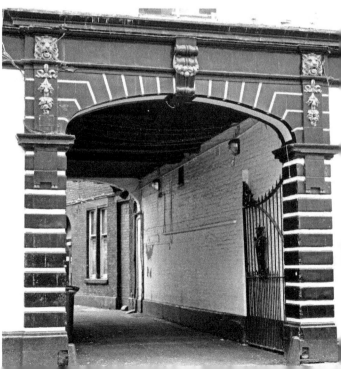

The coming of the railways in the 1830s took away the passenger and mail market and the age of the stagecoach was over. The Lion continued to flourish as an inn, partly due to its large assembly room, which held more genteel dances in the mid-nineteenth century and served as a concert venue for upcoming stars such as Paul Simon, Elton John and David Bowie a century later.

15. Friends' Meeting House

Hidden away between Buttermarket Street and Academy Way is the understated building of the Friends' Meeting House. The Friends, or Quakers, have been associated with Warrington since the late seventeenth century and had strong links with Penketh. This town-centre site has been used by Warrington's Quakers since 1725 but this building dates from 1829–30. It is a simple brick building with a semicircular porch on the south front and its interior is similarly functional. There are no brightly coloured stained-glass windows, organ, ornate altar screen, boxed pews or raised pulpit. This is in keeping with the Quaker form of worship, which does not have a prescribed order of service or appointed minister. The Friends' Meeting Room with its plainly carved benches is a place of largely quiet contemplation unless those attending feel called to speak. The Meeting House garden is also a small oasis in the busy town centre and several members of the Crosfield family were laid to rest in the old burial ground.

The Friends' Meeting House is a hidden gem behind Buttermarket Street.

The Meeting House's plain interior does not detract from private worship.

16. The National School

The former national school in Church Street is an interesting example of what happens to a historic building that can no longer be used for its original purpose but the upkeep of its fabric makes it expensive to maintain for other uses. Today, only the facade of the building is original as the rest of the structure was demolished in the 1980s and new apartments were created that adjoin the feature wall. This retains the inscription of 'National School Supported by Voluntary Contributions' and identifies the two separate entrances for boys and girls and the date of its construction as 1833.

Behind this rather forbidding turreted facade, 328 boys and 204 girls arrived in February 1834 for lessons at Warrington's first primary school. Education was not compulsory then and poorer children were often expected to work long hours in local factories. Horace Powys, the new Rector of Warrington, obtained a government grant and charitable donations to set up a school promoted by the National Society for Promoting Religious Education, which intended to provide basic education to poor children in line with the teachings of the Church of England. Each child attending was still expected to pay a penny a day to the teacher and those who defaulted were excluded. The school

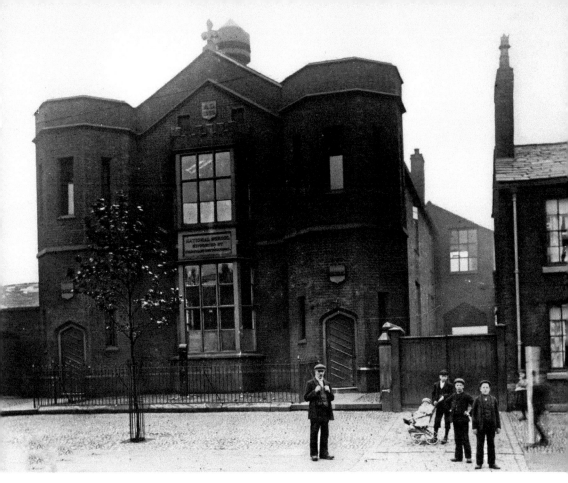

Above: The national school *c.* 1900s with the adjacent terraced housing.

Below: Only the facade of the former national school in Church Street survives.

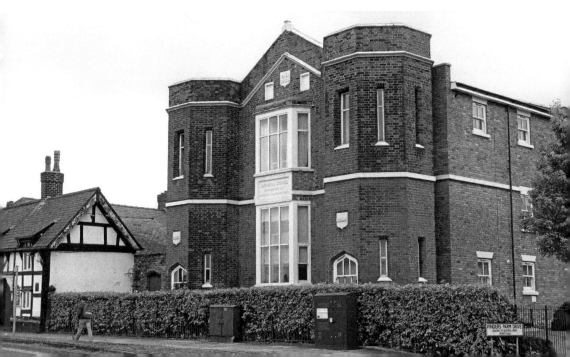

used a system promoted by Dr Andrew Bell and Joseph Lancaster, which enabled large numbers of pupils to be taught with minimum staffing costs. The teacher would instruct older pupils, called monitors, who would then pass on the lesson to the others. The lessons took place in large rooms with several classes sharing the space with the teacher, who was merely a supervisor. Religious education was a key part of the teaching and the minute books of the national school give the first record of the existence of Warrington's Walking Day in 1834.

The national school eventually became part of the state education system in the twentieth century but the building could not be adapted for new teaching methods. After a period as a camping supplies store, its fate was uncertain, but as the building was in a conservation area complete demolition was rejected. The resulting compromise retains the aesthetic appearance of the building but its true function is hard to appreciate.

17. Whitecross Workhouse and Infirmary

Part of the vast complex of Warrington & Halton's NHS Foundation Trust Hospital on Lovely Lane contains the now-hidden history of Warrington's Workhouse. Those generations who have grown up in the post-Second World War world of the welfare state are fortunate not to have experienced the stigma attached to being forced to enter the workhouse.

As Warrington's population grew in the nineteenth century, the town's officials were responsible for those who could not earn enough to care for themselves. This included orphans, deserted wives or widows, the elderly and the chronically sick. The industrial

Warrington's original workhouse in Church Street can be seen on the right.

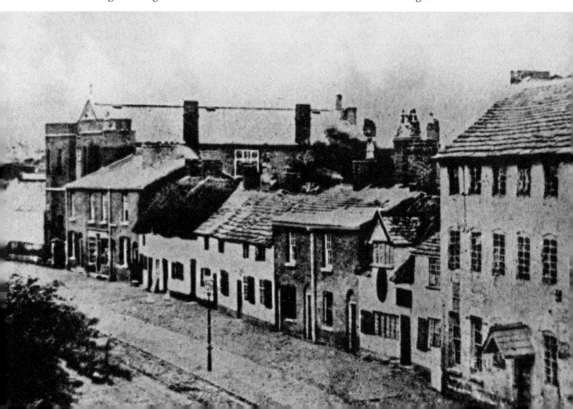

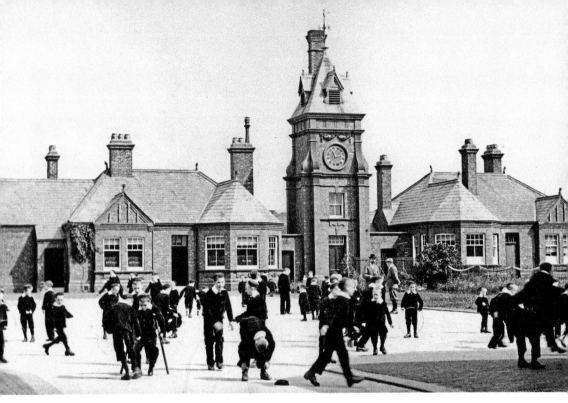

Above: Padgate Industrial School, *c.* 1900.

Below: The Kendrick Wing of Warrington's hospital was originally the workhouse infirmary.

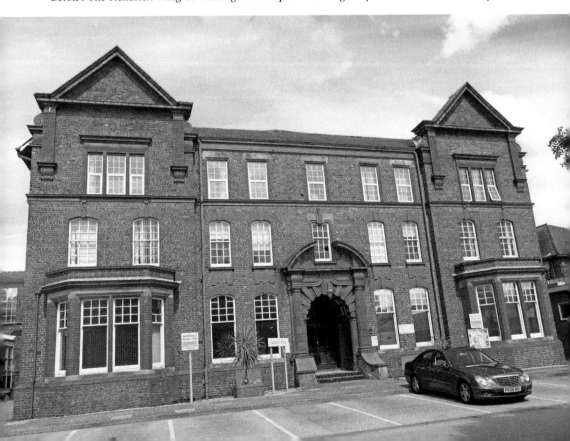

revolution had also seen large numbers of people on the tramp from the countryside in search of work in the towns and who might need support from the parish. Those in desperate need had to enter the workhouse as there was no benefits system.

The Poor Law of 1834 had grouped areas into Poor Law Unions, which for Warrington covered the area of Warrington, Newton-le-Willows, Hulme, Penketh and Cuerdley. This meant that the guardians who administered it could potentially be responsible for 28,000 local residents, plus the so-called vagrants passing through. The existing workhouse in Church Street was inadequate and in 1849–51 a massive new complex was built off Lovely Lane with its entrance in Guardian Street.

To house the long-term residents, an E-shaped building had rooms for 314 men and 314 women and even married couples and brothers and sisters were segregated. There were separate casual wards for vagrants, an infirmary, an isolation ward, a dining hall, kitchens and a chapel. In 1880-81 the union set up a separate industrial school at Padgate to provide accommodation and training for 200 poor children.

In 1899, a larger infirmary designed by William & Segar Owen was opened to provide a central administration block with separate male and female wards alongside. This was a less austere building than the earlier workhouse, with Owen's typical decorative terracotta decoration and glazed tiled panels in the entrance. After the birth of the National Health Service in 1948, the original workhouse became known as Whitecross Homes and Hospital while Owen's Infirmary became Warrington General Hospital and more recently the Kendrick Wing.

18. Warrington Museum and School of Art

In May 1848, Warrington Borough Council created a unique institution, the first museum and library to be founded under the 1845 Museums Act. Warrington claimed to have 'the first public museum in a manufacturing district' and also the first public library in the country. The people of Warrington flocked to make use of their new facility, and by 1853 it had outgrown its temporary premises in Friars Gate and the search began for a new home. Thanks to the generosity of local landowner Mr Wilson Patten, a site was found off Bold Street. Plans for an ambitious building were commissioned from leading architect John Dobson and then rejected because of their cost.

A more affordable option from Mr Stone of Newton-le-Willows was accepted and work could finally begin. Referred to by its supporters as a 'Home for the Muses', the building was intended to make art, literature and science accessible to all. The three-storey building would include galleries, a reading room, a library and space for the School of Art. The foundation stone was laid on 22 September 1855 by William Beamont and the building opened in December 1857. A committee of fundraisers had ensured that much of Stone's plan was completed but only one of the three intended top-floor galleries appears to date from this period. As well as the museum galleries and a reference library, the building was also the first home of Warrington's School of Art, which was organised by the Mechanics Institute to provide an education that would allow young artists to find employment in industry. The school flourished under J. Christmas Thompson and produced artists such

as Luke Fildes, who became an established graphic artist, illustrating works by Charles Dickens and later a member of the Royal Academy.

Between 1873 and 1874, plans were drawn up for an extension along Museum Street on 600 square yards of land given by Col Patten. On the ground floor was more space for the library and upstairs a new art gallery, which was officially opened on 4 October 1877 by the mayor, Samuel Mather Webster, a leading supporter of the School of Art. However, it was already clear that the school needed purpose-built accommodation and in November 1883 the new School of Art, designed by local architect William Owen, opened in Museum Street.

By the 1930s, the museum and library were separate entities sharing one building, which featured a magnificent new domed lending library with art deco influences and additional museum galleries. Despite further remodelling in the 1960s, the museum has retained its distinctive character by sensitively adapting its Victorian galleries while developing a reputation for its contemporary art exhibitions. In 2012, Warrington Borough Council commissioned Culture Warrington to operate and develop the museum on its behalf. In 2013, a new 'Cabinet of Curiosities' gallery was opened with support from the Heritage

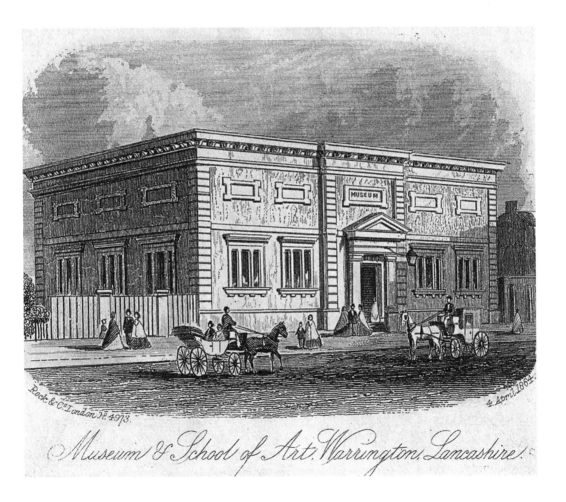

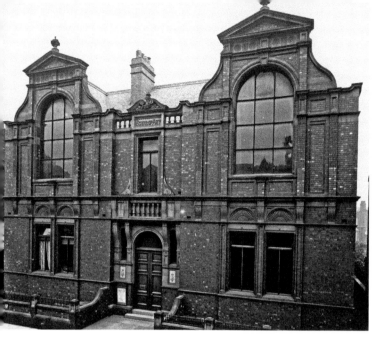

Left: The new purpose-built School of Art in Museum Street, *c.* 1890.

Right: The art deco interior of the 1930s' lending library.

Lottery Fund to showcase the extensive and historically important diverse collections. To celebrate the museum's 170th anniversary in 2018, it is hoped to recreate the Victorian vision of its founders by developing the building as a Centre of Excellence for Cultural Heritage.

19. Garnett's Cabinet Works

In 1864, Robert Garnett & Sons opened their extensive new showrooms and warehouse in Sankey Street, designed by Chester architect John Douglas. Garnett's described their new premises as 'an imposing four-story stone edifice in the Gothic style of Architecture'. Unfortunately, Douglas' full vision has been lost with the removal of the arched lower windows and ironwork on the roof and at balcony level, it is clear that this premier firm of cabinetmakers needed a vast space to show their large-scale furniture. They supplied grand private houses, town halls, clubs and offices throughout the country with furniture made initially at their Penketh works.

Between 1906 and 1908, Garnett's erected new cabinet workshops behind the shop in Barbauld Street, which were 'built to the most scientific and labour saving plans in order that the manufacture of furniture may be carried on under ideal conditions as regards economy in working'. The most distinctive feature of the workshop was its crenulated Italian Renaissance-style water tower, which stood out on the skyline of Warrington's townscape.

Garnett's grand shop was occupied by a series of low-cost chain stores from the 1920s, including Woolworths, which closed in January 2009. The workshop has long stood empty without a viable use and by 2016 the landmark water tower was in danger of collapsing.

Messrs. Garnetts' Works, Warrington.

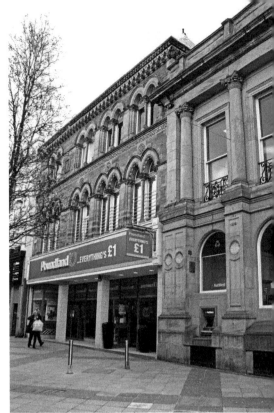

Above left: Garnett's cabinet workshop was hidden away behind Sankey Street.

Above right: Formerly Woolworths and later Poundland, this Gothic frontage housed Garnett's grand showroom.

Below: The tower of Garnett's workshop is a distinctive landmark in the town centre.

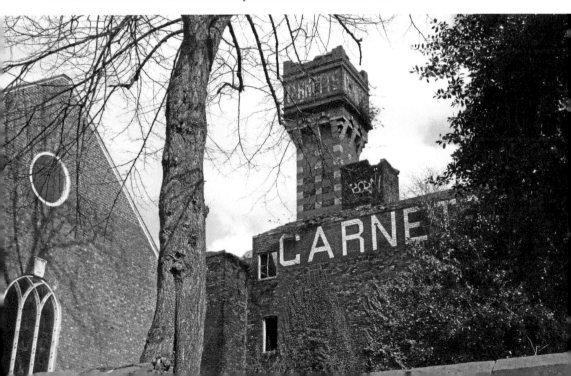

2c. Central Station and the Cheshire Lines Warehouse

During the nineteenth century, railways replaced canals as the country's main transport network and passengers and goods needed new railway stations to replace the stagecoach inns. By the mid-1850s, Warrington had Bank Quay station for links to London and Arpley station serving the line linking Liverpool and Stockport, but still had no major station on the route between Manchester and Liverpool.

By the early 1870s, the Cheshire Lines Railway (CLC), which was owned by a group of railway companies, decided to build a new line between Liverpool and Manchester to the south of the original railway that had opened in 1830. The CLC were persuaded to build a loop line between Bewsey and Padgate with a terminus at the aptly named Central Station, which opened in 1873. Much of the original Victorian decorative cast-iron work can still be seen on the station's platforms but the original high-level grand entrance has given way to a twenty-first century version at street level.

Construction of the line cut through the grounds of a grand eighteenth-century mansion called Beech House, which was owned by the Edelsten family, who were local industrialists. Beech House fell into decline and was eventually demolished in the late twentieth century. However, one other listed building at the station site has survived with the remodelling of the former Cheshire Lines warehouse, dating from 1888. In 2005, planning permission was finally granted for the warehouse to be converted into flats with the construction of four adjacent blocks of flats. The building had been empty for decades with a variety of plans suggested for conversion into offices, a restaurant, a shopping centre and even a nightclub, but with the failure of each proposal demolition loomed. Today, the grand exterior with the names of the Cheshire Line companies is again proudly visible.

The distinctive Victorian cast-iron work on Warrington's Central Station's platform.

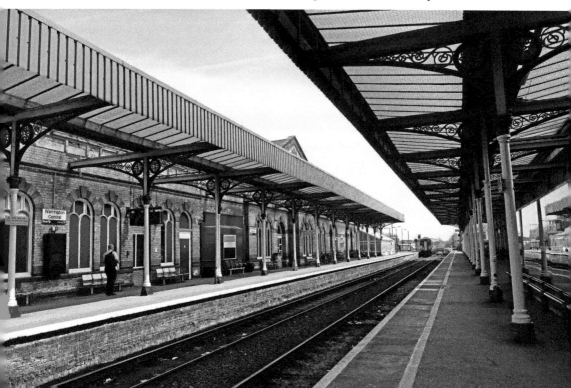

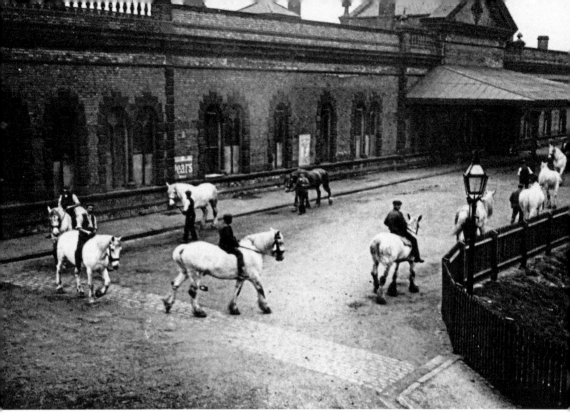

Above: The original grand entrance to Warrington's Central Station during the 1913 railway strike.

Below: The restored Cheshire Lines warehouse behind Warrington's Central Station.

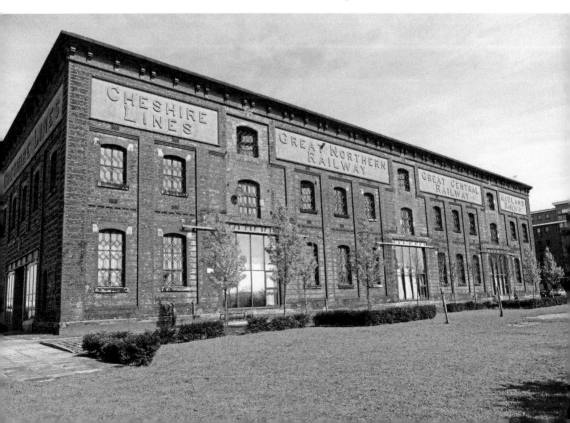

21. Peninsula Barracks

This impressive fortress dates from 1878 and was built when the army was reformed to ensure it could serve Britain's growing empire. It became the base for the South Lancashire Regiment, which formed in 1881, and the associated Prince of Wales Volunteers, who were recruited locally. Unlike many of its European neighbours, Britain did not have a large standing army and in the event of an invasion it would rely on local volunteers to supplement the professional soldiers.

If Britain was at war, the volunteers could be asked to serve overseas and this was put to the test in the Boer War (1899–1901), which was fought in South Africa. Led by Gen. Sir Redvers Buller, troops were sent out from Britain and hundreds of men from Warrington and the surrounding area joined the South Lancashire Volunteers. In February 1900, the regiment was involved in heavy fighting to relieve the town of Ladysmith and Lt-Col McCarthy O'Leary and many of his men were killed in action at a battle at Pieters Hill. O'Leary Street next to the Peninsula Barracks was renamed in his honour.

During the First World War, the barracks were crucial to the training of new recruits and also had a military hospital, which opened on 4 August 1914 with one ward of thirteen beds. Almost 100,000 patients were treated at Orford Barracks, although most were outpatients.

By 1970, the South Lancashire Regiment had been incorporated into the Queens Lancashire Regiment but the town's long association with the regiment continues. The Peninsula Barracks is still used as an army reserve base, most recently for the 75th Engineer Regiment.

The Peninsula Barracks off O'Leary Street and Marsh House Lane.

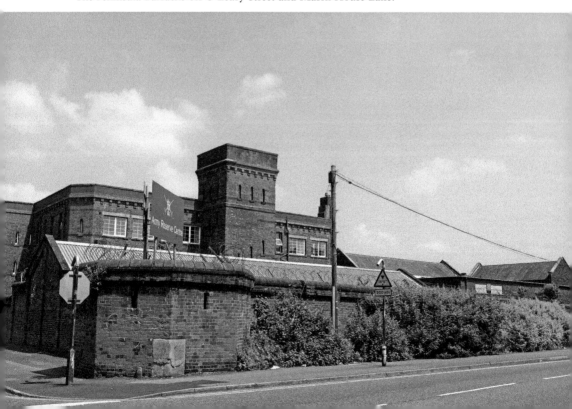

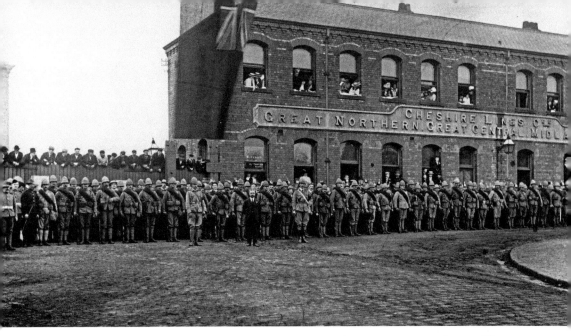

South Lancashire Volunteers assemble at Warrington's Central Station en route to the Boer War.

22. St Mary's Church, Buttermarket Street

By 1820, Roman Catholics were free to worship openly in the country and St Albans in Bewsey Street, the first purpose-built Catholic church in the town, opened in 1823. As the influx of Irish migrants grew between 1850 and 1870, many settled in the courtyards

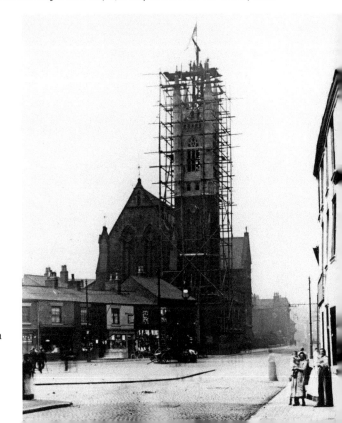

St Mary's Church tower in Buttermarket Street nears completion in 1906.

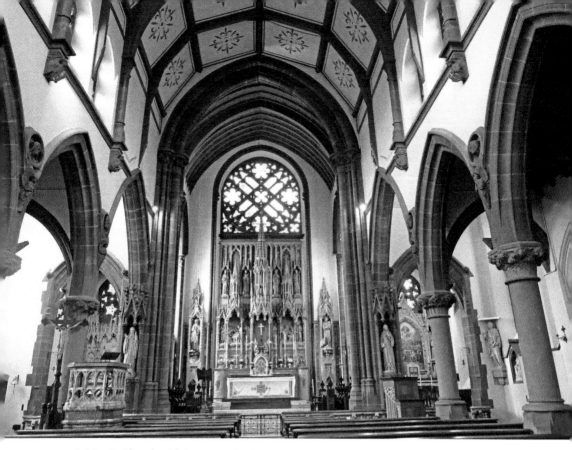

St Mary's Church with its ornate Pugin interior.

behind Bridge Street; in 1877, St Mary's Church in Buttermarket Street was built on the site of a former cotton manufactory to serve this new congregation.

St Mary's comparatively plain exterior hides a typically exuberant Pugin interior designed by several members of the firm. It has many of the features associated with a medieval cathedral, with a lofty chancel and nave, stencilled ceilings, tiled flooring, clerestory windows, stained glass, carved wooden choir stalls, an organ case and a soaring pulpit. Fittingly, its greatest glory is the high altar with its alabaster carvings and flanked by saints. The bell tower was a later addition, with its bells finally ringing out on Sunday 28 October 1906.

23. Greenall's Brewery

By 1791, the Greenall brewing dynasty was already well established at Wilderspool, headed by St Helens brewer Thomas Greenall, who had seen a business opportunity at the existing Saracens Head site. Good supplies of pure well water and ample quantities of locally grown grain for malting, together with a good transport network and wealthy investors, made Warrington an ideal choice for expansion. Rivals like Walker's (later Tetley Walker) and Burtonwood Ales followed but the Greenalls integrated into local public life, becoming not only major employers but also, in Sir Gilbert Greenall's case, the town's MP, with a fine residence at Walton Hall.

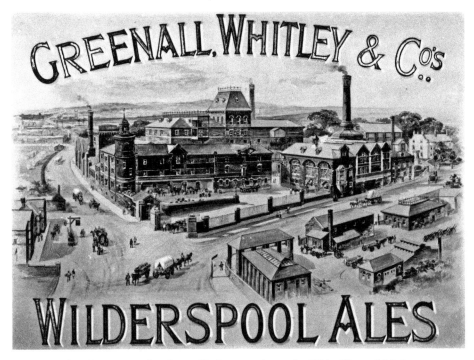

A 1900s' advertising poster for Greenall's Brewery shows the White House (right).

By the early 1900s, the Wilderspool Brewery had been completely rebuilt and housed the most modern equipment, an extensive hop store, new bottling stores and cooperage works, yards and offices while their earlier on-site home of the White House remained as offices. The firm owned a number of licensed houses in Lancashire, Cheshire, North Wales, Shropshire, Staffordshire and other areas as well as the majority of the hotels and inns in Warrington.

From the 1960s, brewing was no longer a profitable industry. Gradually, historic pubs were put out of business by the high tax on beer compared to other alcohol and competition from cheap beer on sale in supermarkets. In 1991, Greenalls ended the brewing of beer at Wilderspool after a continuous history of almost 250 years, and in 1999 disposed of all their public houses and restaurants to their bitter rivals, Scottish & Newcastle. The Wilderspool brewery site now has conservation area status, including the brewhouse, malt buildings and the White House and is largely a gated business park and an adjacent supermarket.

24. Walton Hall

For the last sixty years, Walton Gardens have been a popular local leisure destination but once these were part of the private estate of the Greenall brewery dynasty. In 1814, Edward Greenall, son of the brewery's founder, planned to move away from the White House in the middle of the brewery complex. He purchased an estate at Walton to establish himself as a country gentleman but after his death in 1835 his youngest son, Gilbert, became the hall's

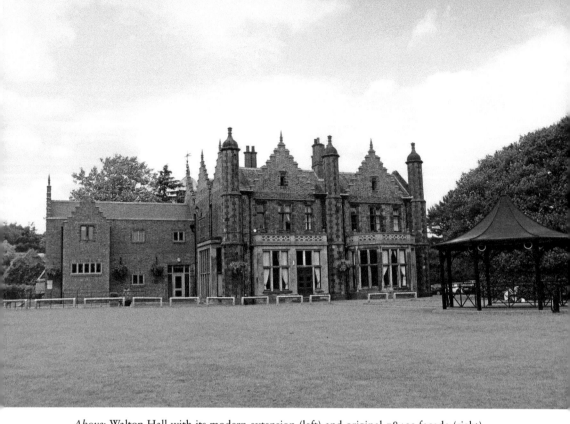

Above: Walton Hall with its modern extension (left) and original 1840s facade (right).

Below: Walton Hall in the 1950s with the Scottish-baronial style 1860s extension (left).

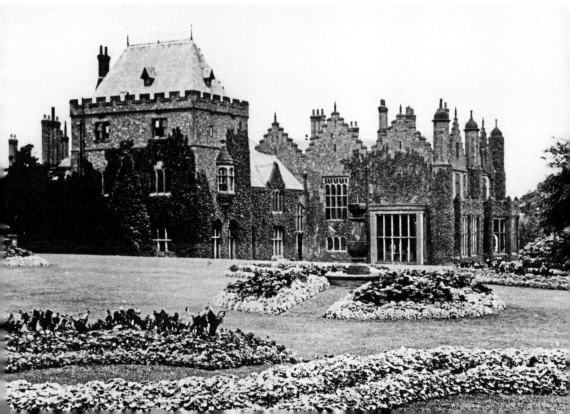

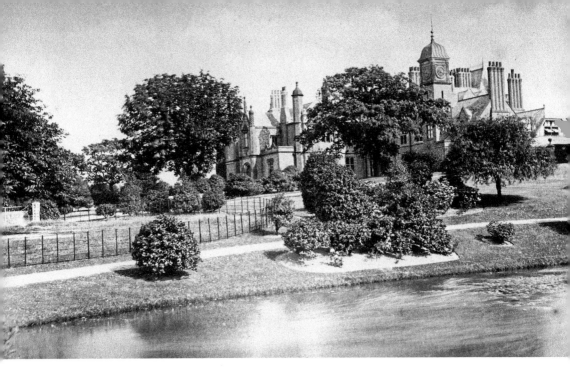

Walton Hall from across the lake around 1900 showing the distinctive clock tower.

first occupant. The first phase of Walton Hall was an Elizabethan-style house with stepped gables and distinctive pinnacles. A square block of family rooms with a side entrance porch had extensive servants' quarters and a stable block to the rear.

In the late 1860s to mid-1870s, the hall was extended to accommodate the children of his second marriage and the enlarged household deemed necessary for his new social status as a baronet and Warrington's MP. The small side porch was replaced by a new wing in the popular style imitating a Scottish castle, with a square tower containing a fashionable billiards room. Sir Gilbert's son, later 1st Lord Daresbury, added a further wing with a distinctive clock tower nearer to the driveway. He developed Walton as a model agricultural estate while his wife, the formidable Lady Daresbury, developed the grounds as botanical gardens.

The death of Lord Daresbury in 1938 signalled the end of the Greenall era at Walton and the estate was put up for sale in July 1941 to meet the death duties. Warrington Borough Council bought the hall and 171 surrounding acres for £19,000, intending to develop them as a public park. The opening was delayed until 19 May 1945 due to the Second World War when the greenhouses were taken over to grow food. No longer a family home, Walton Hall began to decay and in 1978 much of the post-1860s alterations were taken down with the remainder restored for function spaces. In 2016, plans were announced to restore the grand conservatory and other outbuildings to reflect the estate's agricultural heritage.

25. The Manchester Ship Canal, Latchford

Built between 1885 and 1894, this huge engineering project altered the local landscape and the old river and canal network around Warrington. Although it gave local industry another link to the ports of Liverpool and Manchester, the planned Warrington docks were not

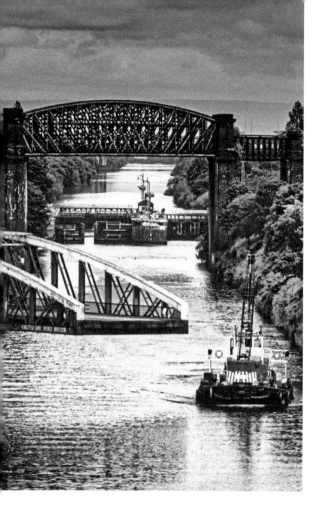

Left: The Manchester Ship Canal at Latchford locks. (Photo © Rob Gresty)

Below: This 1890s' photograph shows the canal's impact on the Latchford landscape.

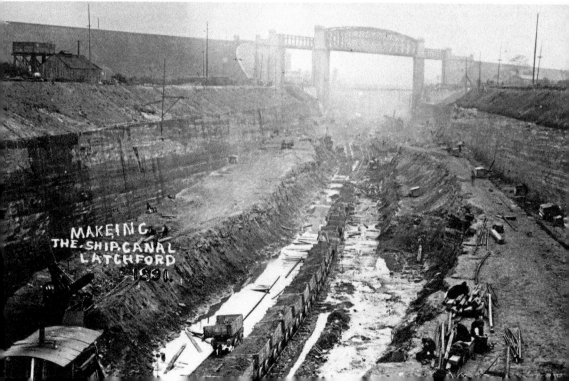

developed on the scale anticipated. By its completion in December 1893, 17,000 'navvies' had shifted 54 million cubic yards of soil and rocks to create the 35.5-mile-long canal at the then staggering cost of £15 million. New sections of waterway through Warrington were linked to the River Mersey to enable ocean-going vessels to reach the new inland port of Manchester and the neighbouring Lancashire cotton towns.

The cutting of the canal had a dramatic impact on the landscape of south Warrington. Latchford was cut off from Thelwall and Grappenhall, and Wilderspool was isolated from nearby Stockton Heath. Today, the greatest feats of engineering can be seen at Latchford with its parallel hydraulically operated locks, the larger of which is 183 metres long and 20 metres across. The sluice gates behind the smaller lock control the flow of water and maintain a constant level. Towering above the locks is the railway viaduct which was built to carry the now-closed London & North Western Railway line.

While the Latchford viaduct allowed the tallest ships to pass beneath, nearby Knutsford Road Bridge is one of a series of swing bridges through the town that allow ships to pass through the area's road crossings. As shipping on the canal declined by the mid-twentieth century, this nineteenth-century solution to Warrington's traffic infrastructure created major traffic bottlenecks in the town, which even the nearby Thelwall Viaduct has failed to resolve.

26. Town Hall Gates

When Bank Hall was purchased as Warrington's new town hall, it was barely visible from Sankey Street as the Patten family had built a high brick wall to give them privacy from the growing traffic. Soon there were complaints from some ratepayers that since they were paying towards the building's upkeep they ought to be able to see it! Frederick Monks, one of the town's earliest councillors, came up with a solution that enabled him to be a benefactor to the town; this was in keeping with his role as a local ironmaster and he graced the town hall with a fitting entrance.

As a young man, Monks had been the protégé of P. P. Carpenter of Cairo Street and had worked his way up to become a partner in creating Monks Hall & Co., which became one of the country's leading manufacturers of iron and steel. Through his business connections, he learnt of a magnificent pair of iron gates made by the famous Coalbrookdale works at Ironbridge, which he bought and presented to the town on 28 June 1895.

These grand gates were originally designed for the International Exhibition of 1862, and potentially for Queen Victoria's Sandringham home in Norfolk. Unfortunately, the queen was diverted from their trade stand at the exhibition as a cast iron statue of Oliver Cromwell was clearly visible through the gates. As one of the signatories of Charles I's death warrant, Cromwell was understandably not popular with royalty and courtiers realised she would not be amused to see Bell's statue. It was because of this that Coalbrookdale had found it difficult to find an alternative market for gates on this scale and Monks was able to acquire them for the town. To link them to Warrington, the central Prince of Wales' motif above the centre arch was replaced with Warrington's coat of arms.

Such grand gates needed a suitably grand opening and Warrington's annual walking day provided the ideal occasion since the town hall lawn was crowded with all the participants and spectators. Monks ceremoniously opened the gates with a golden key to allow the

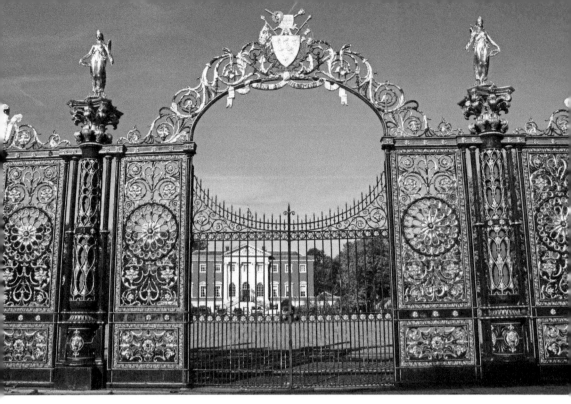

Above: Warrington's golden gates were made at the famous Coalbrookdale Ironworks at Ironbridge.

Below: Frederick Monks presents the gates to the town on Warrington Walking Day 1895.

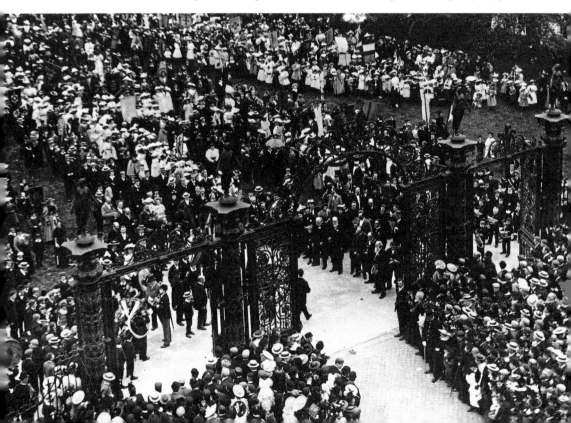

assembled churches to set off on their procession. If the walkers thought they were being watched over by four angels on the gates, they were mistaken – the four winged figures represented Nike, goddess of victory, as a reference to their intended owner, Queen Victoria. The figures had also been sculpted by Bell and Monks later presented the offending statue of Cromwell to the town, as he shared Cromwell's Protestant faith.

27. Parr Hall

Parr Hall was presented to the town as a public hall in 1895 by J. Chorlton Parr, a member of the wealthy local banking family. It was designed by local architect William Owen but its plain style is a contrast with many of his later public buildings around the town, which saw him being commissioned to design some of William Lever's model village at Port Sunlight. In 1925, the Parr Hall's original organ was replaced by a rare Cavaillé-Coll organ as choral concerts could still attract large audiences.

Parr Hall has been a much-loved concert venue for over a century with concerts ranging from excerpts from *Judas Maccabeus* at the opening performance in 1895 to the Rolling Stones and later Stone Roses' comeback gig in 2012. In the First World War, the Parr Hall took the role of Warrington's war office, serving as a centre for relief operations for prisoners of war and the families left behind. It has hosted numerous public events and posters for many local outdoor events had the cautionary note, 'If wet; in the Parr Hall'.

The plain facade of the Parr Hall looks out over Queens Gardens.

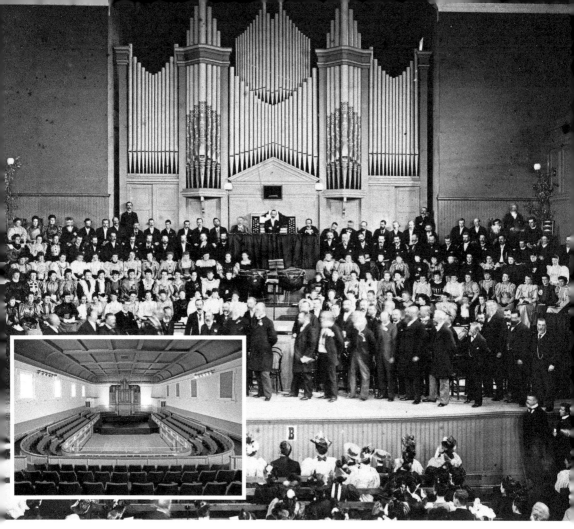

The official opening of Parr Hall in 1895 and the original organ. *Inset*: Parr Hall and the later Cavaillé-Coll organ.

28. The Technical College

William and Segar Owen's design for the Technical College, built in 1900–1901, is in complete contrast to the practice's earlier adjacent Parr Hall. The imposing seventeenth-century-style entrance led into a grand staircase with large windows; leading off the original corridors are smaller rooms for classes of the technical education curriculum, introduced as part of education reforms of the late nineteenth century. To encourage the students, the Owens embellished the ornate facade with terracotta reliefs celebrating famous scientists.

By the mid-1960s Warrington Girls High School, the last Warrington education institution to occupy the building, had relocated to a site off Wilderspool Causeway. The site became Warrington Borough Council's treasury department before being sold for development. Plans for a boutique hotel were abandoned in favour of conversion into a restaurant complex to complement the town's new Cultural Quarter centred on Palmyra Square.

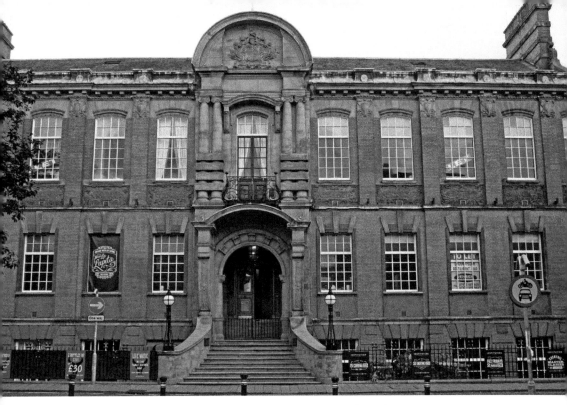

Above: The former Technical College in Palmyra Square, currently undergoing conversion into restaurants.

Below: William & Segar Owen's design for the Technical College.

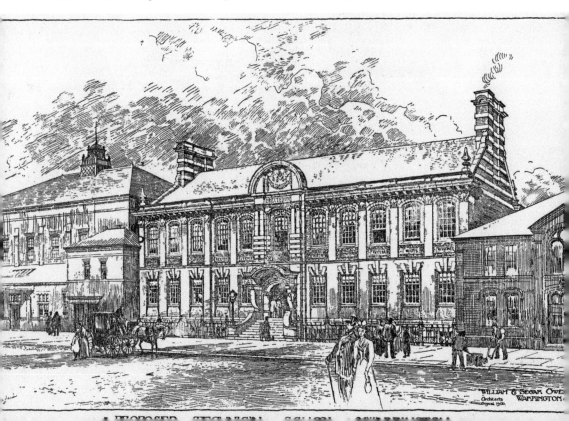

29. Arpley Street Police Station

When the Borough of Warrington was created in 1847, the town had one police constable and four assistants to maintain law and order in a town of 24,000 inhabitants. Their base was the old Sessions House and bridewell (prison) in Irlam Street off Buttermaket Street. This imposing building had been built to withstand a siege by rioters and contained the courtroom and prison cells, which continued to be used after the constables moved to a more central base in Warrington Market Place. By 1901, the town's population had reached almost 65,000 and the police force of about seventy officers were relieved that they could finally move into a modern purpose-built police station in Arpley Street. The building was conveniently located close to the newly opened county court in Winmarleigh Street.

In 1898, Newcastle-based architect Robert Burns Dick won the competition for a design for 'new Constabulary offices, lock up, police and coroners court and mortuary'. There would also be a parade room, a dormitory for thirteen single men, witnesses' rooms and offices for the coroner, solicitors and magistrates. The ornate interior also featured stained-glass windows, which helped the building gain the local nickname of the 'Palace of Justice'. Some critics thought that the building's eclectic Free Renaissance design was too elaborate for its purpose; it featured an elaborately moulded terracotta facade, gables and turrets that looked like minarets, but others felt it gave the public institution a suitable presence in the town.

The old bridewell and police station in Buttemarket Street, *c.* 1900.

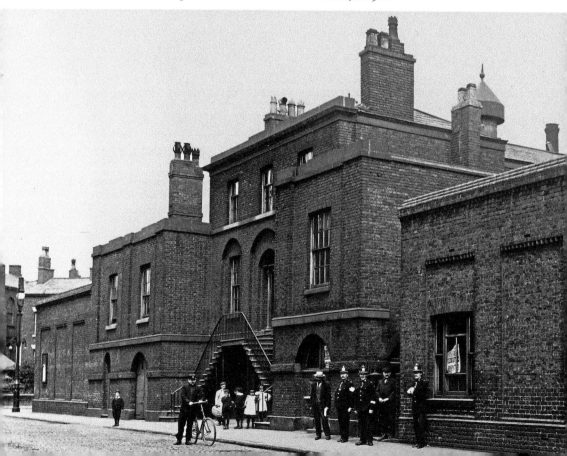

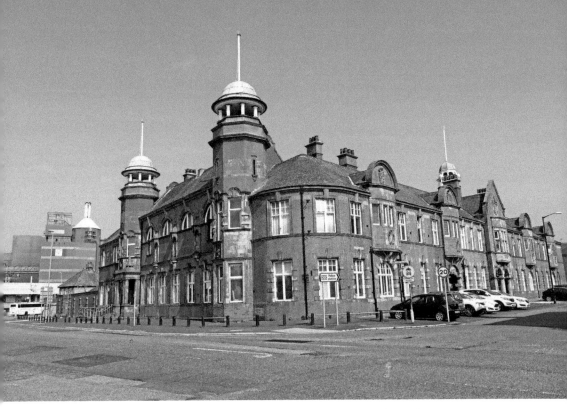

The eclectic architecture of Warrington's Arpley Street police station dating from 1901.

The building was officially opened on 11 October 1901 by Alderman Henry Roberts JP, who was also Warrington's mayor and Chair of the Watch Committee. Unfortunately, not all of the building was ready for business and some of the architect's more ambitious plans were discarded. The grand courts on the first floor facing Wilson Patten Street were ready for their first hearing but initially the prisoners still had to be brought over from the old cells in the Irlam Street bridewell. Fortunately, all was soon in order and Arpley Street served the force for almost a century until the demands of modern policing methods, advances in technology and centralisation of functions meant it was no longer fit for purpose. The old cell complex fittingly became the Museum of Policing in Cheshire while the long-term future of the building was decided.

30. Palmyra Square

In the 1840s, new buildings appeared in Cairo, Egypt and Suez streets, which were named after the local South Lancashire Regiment's recent battles against the French in Egypt. By the late 1880s, another Middle Eastern name had appeared on the map as Palmyra Square was developed. Private houses were built in Bold Street and to the north and south of the square, and their owners had keys to the shared walled gardens in the centre of the square.

These private gardens were purchased in 1897 as a park to celebrate Queen Victoria's Diamond Jubilee and opened to the public on 17 October 1898. When Warrington wanted to honour members of the South Lancashire Regiment killed in the Boer War, what better place to site the memorial than in the gardens named in the honour of the

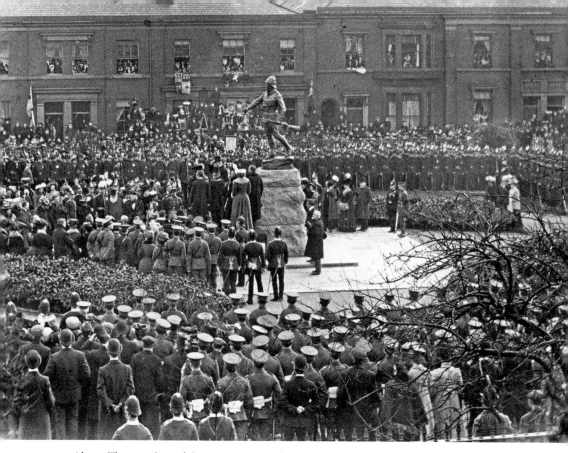

Above: The unveiling of the statue to Lt-Col O'Leary in February 1907.

Below: Queen's Gardens and its memorial to the Warringtonians killed in the Boer War.

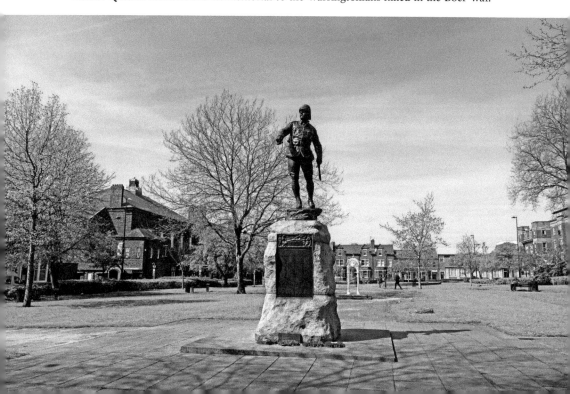

late queen? In February 1907, an expectant crowd arrived in Queen's Gardens to witness Gen. Sir Redvers Buller unveil the memorial at the invitation of the sculptor, Alfred Drury. The bronze statue 'represented the late Colonel McCarthy O'Leary as he appeared in the Battle of Pieters Hill where he fell directing his troops'. Commemorative plaques also record all the men of the regiment killed in the South African campaign and each year the memorial is the scene of a ceremony commemorating the town's links with the regiment.

By the early 1900s, the private houses in Palmyra Square were becoming offices and the south of the square was completed by a sequence of public buildings that ensures the area conservation status at the heart of the town's Cultural Quarter.

31. The Howard Building

During the redevelopment of Bridge Street in the 1900s, this impressive building replaced a fairly unremarkable block of three shops. However, the site had links with John Howard, the noted eighteenth-century prison reformer, and the elaborate facade of the building reflects this important connection. Howard lodged at a silversmith's shop on the site in the 1770s while he was completing his work on *The State of the Prisons in England and Wales*, which was being printed by William Eyres Press in Horsemarket Street.

The new building has terracotta reliefs showing Howard helping to free prisoners from some of the harsher conditions they endured and a plaque marking his stay in Warrington, which was designed by Garnett & Wright and commissioned by the Warrington Society. The unveiling ceremony took place on 5 April 1907, the 130th anniversary of the publication of Howard's work.

Unveiling the plaque commemorating John Howard's links to Warrington in 1907.

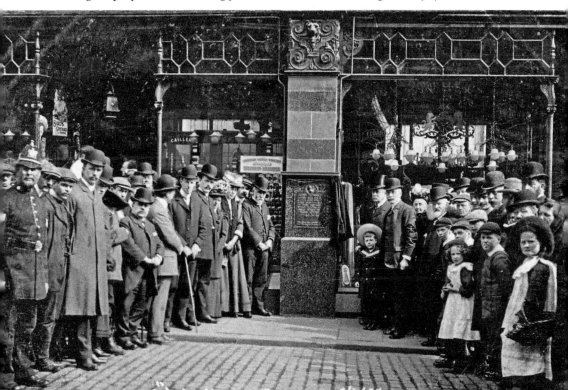

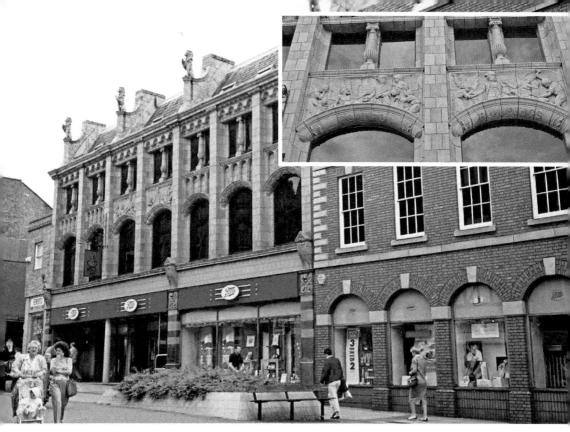

The Howard Building in Bridge Street in the 1990s. *Inset*: Scenes on the building's facade commemorate Howard's career as a prison reformer.

Sadly the Howard Building, then occupied by Boots chemists, was near the site of the Warrington bombings of 20 March 1993 and a new plaque in remembrance of this tragic event meant Howard's was relocated to an adjacent pillar. The facade of the Howard Building will be an important feature of the regeneration of Bridge Street, due for completion by 2019, when the building will have a new life.

32. McDonald's, Bridge Street

This imposing shop was originally built for the Bridge Street bakery and foodstuff business of the Carter family, which was founded in 1834. Their new premises were completed in 1907 near to their previous store, which was then adjacent to Patten Lane. On Wednesday 8 August 1917, an electrical fault sparked a fire that swept through the building in the early hours of the morning. The fire spread rapidly because of the flammable grain, flour and cattle food stored there. Warrington's fire brigade fought the blaze for several hours but the foodstuffs and bakehouse were destroyed; there was over £22,000 worth of damage done to the building itself, which was only partly insured.

The fire was disastrous for Warrington's food supplies as by 1917 the First World War was causing a national shortage of food. By February, Germany had resumed submarine warfare and was attacking ships heading to Britain, who was importing about two-thirds of her food supply. It was also clear there would be a shortage of male workers to bring in

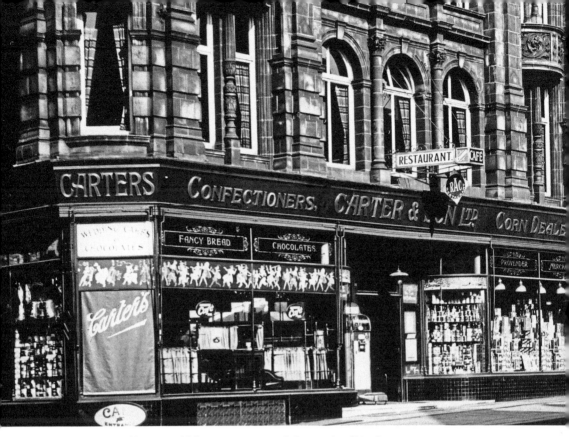

Above: McDonald's original life as Carter's grand shop and café in the 1920s.

Below: McDonald's Bridge Street restaurant has a corporate frontage at ground level.

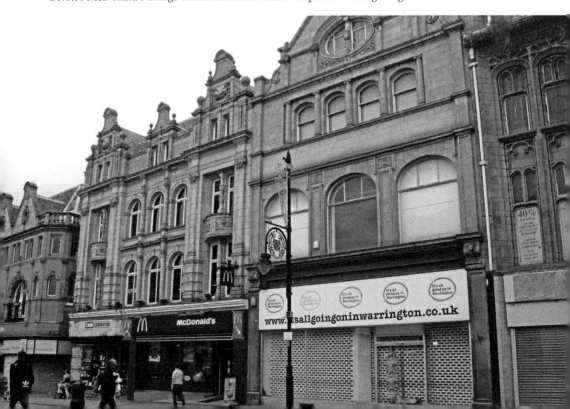

the crucial harvest at home that year and German prisoners of war were drafted in to work the land.

Due to wartime building restrictions, only Carter's bakery was immediately rebuilt and it took a further three years before Carter's Bridge Street shop reopened with an expanded confectionary department. Later 'an extensive and artistic café and tea room' on the first floor became the grand venue for wedding receptions and special occasions. A century later, McDonald's had taken over the site, branding the ground floor with its corporate image but, like many of Bridge Street's buildings, the distinctive architecture is still clearly visible above street level.

33. The Feathers

By the end of the nineteenth century, Warrington's main streets and Market Place were crammed with centuries-old inns and former coaching houses. On market days these were crowded with weary travellers and traders doing deals on corn or livestock. The old Feathers Inn near the corner of Friars Gate was just one of Bridge Street's many hostelries. The courtyards behind either side of the street offered even more competition for the landlord of the Feathers, who could at least claim that his son, George Sheffield, was beginning to build a name for himself as a successful artist after his time at Warrington School of Art.

The original Feathers Inn to the right of the bow-fronted shop, *c.* 1900.

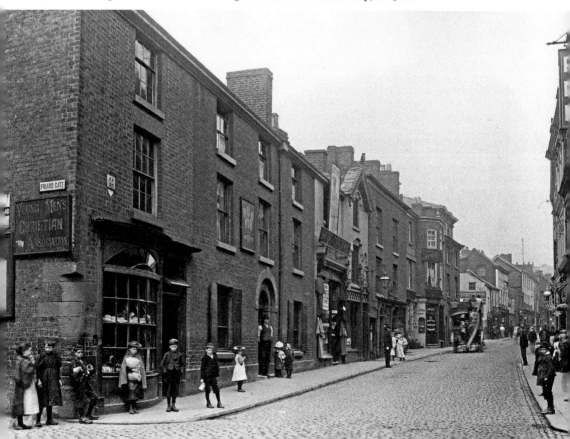

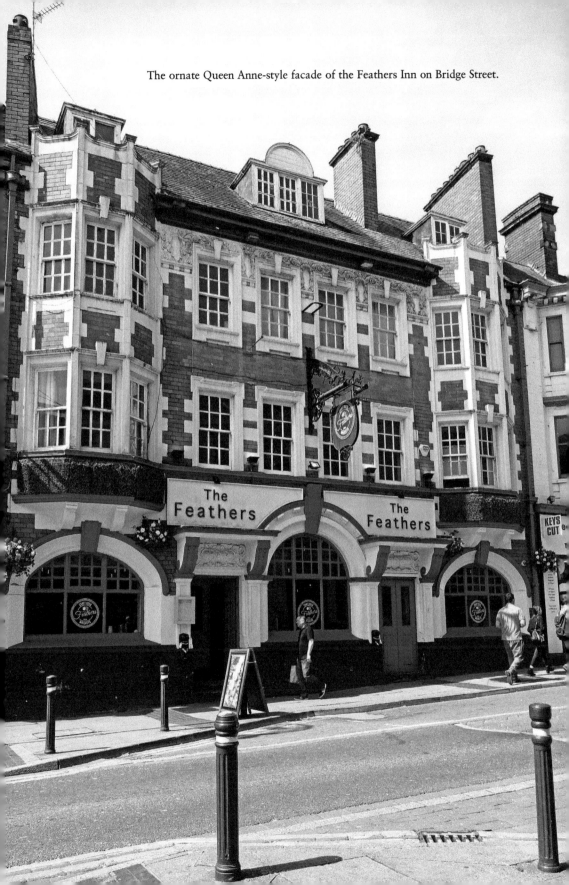

The ornate Queen Anne-style facade of the Feathers Inn on Bridge Street.

As Bridge Street was widened at the turn of the century, a number of the oldest inns disappeared and Greenall Whitley took the opportunity to rebuild many of the public houses that they had taken over to ensure the landlords were tied to supplying only their beers. Rival brewers Walker & Sons developed a similar strategy and, like Greenalls, embarked on a programme of rebuilding larger pubs around the town with imposing facades to tempt the crowds of drinkers. Wright, Garnett & Wright and William & Segar Owen, two of Warrington's architect firms, competed for business and the Feathers was the work of the Owens. Their Queen Anne-style building with its distinctive red-brick front and contrasting white stonework stood out amongst its neighbours and was a world away from its more unassuming predecessor.

34. The Hippodrome

Built in the heyday of variety theatre, the foundation stone of the Hippodrome, designed by Birmingham architect G. F. Ward, was laid on 1 May 1907 by Cllr Smethurst, the Mayor of Warrington. The new venue was commissioned by the Palace & Hippodrome Company at a cost of £15,000 and Davenport's construction firm moved swiftly to ensure the building could open on 23 September the same year. The *Warrington Guardian* declared 'It would be difficult to conceive of a more comfortable and inviting place of entertainment than the latest addition to our local places of amusement.'

The theatre could accommodate an audience of 2,100, who certainly would have marvelled at its lavish architecture, which included an ornately decorated gilded ceiling with

The grand facade of the new Palace and Hippodrome Theatre, *c.* 1910.

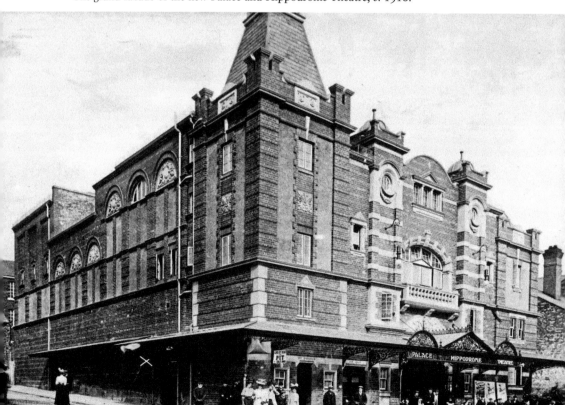

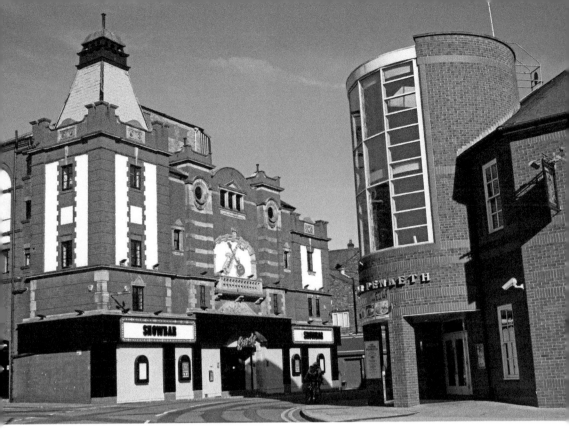

The Showbar off Friar's Gate has retained some of its original facade.

paintings representing music and art while the fronts of the boxes in the circle were picked out in gold and crimson. The opening night's entertainment included 'the Sisters Reno, expert dancers and quick change artistes; Tennyson and Wallis, celebrated comedians …'

The music hall flourished until December 1931 when, after a two-week closure, the venue reopened on Boxing Night as the Palace Cinema. By 1957, entertainment tastes were changing again and at Christmas the Palace became the fourth cinema to close that year as well as the nearby Royal Court Theatre. In 1958, the Warrington Repertory Theatre Club unsuccessfully tried to turn the venue into a theatrical art venue. During the next fifty years, the former Hippodrome operated as a cinema and a bingo hall before becoming Branningan's nightclub and latterly the Showbar.

35. Market Gate

The traditional focus of Warrington's town centre is Market Gate, the crossing point for the original north–south and east–west routes through the town and an early site of Warrington's market. With the rapid expansion of the town in the nineteenth century, the largely medieval street layout could no longer cope with the increased traffic. In the 1900s, Arthur Bennett had successfully lobbied his fellow councillors for the widening of Warrington Bridge and Bridge Street. Through his magazine *The Dawn*, he campaigned for an architectural competition to select a suitable master plan for a unified design for the corners of each of the main streets at Market Gate.

Above: Wright, Garnett & Wright's 1908 designs for Market Gate Circus.

Below: The Buttermarket Street corner of Market Gate during the 1960s with the distinctive roundabout. *Inset*: Installing the infrastructure for the Well of Light at Market Gate in 2001.

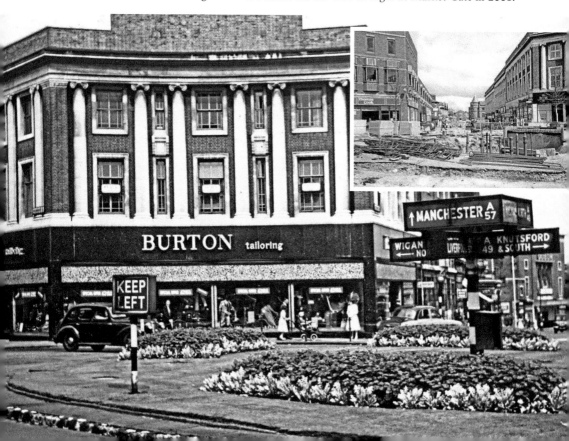

Local architects Wright, Garnett & Wright were chosen by the adjudicator Charles Reilly, professor of architecture at Liverpool University, for their design for a circus in brick and Portland stone. This circular feature had been popular with the eighteenth-century architects of London and Bath and Reilly felt their scheme was in keeping with Warrington's Georgian buildings. Only the north-east and north-west corners (adjoining Bridge Street) followed their plan. The south-east corner at Buttermarket Street, designed for Burton's tailors in the 1930s, reflected the art deco style of the period and the Sankey Street corner of the 1980s was in a much plainer style. Bennett's 1908 vision of 'statues and a fountain in the centre of the spacious circus' took almost another century to be realised.

36. Sankey Street Co-operative Store

While discount stores may have taken over today's high streets, until the mid-twentieth century the 'Co-op' was their earlier equivalent. The Co-operative movement had begun in Rochdale in 1844 at a time when unscrupulous traders cheated the poor by selling inferior goods at high prices. In August 1860, a group of Warrington men, including Revd P. P. Carpenter of the Cairo Street chapel, agreed to set up the Warrington Equitable Industrial Co-operative Society to sell unadulterated goods at fair prices and return a proportion of their profits to the society's members in the form of a dividend.

By the 1900s, Warrington's Co-op was flourishing with branches across the town and its Cairo Street premises were long outgrown. Local architect Albert Warburton, whose offices were in nearby Bold Street, was commissioned to build the Co-op's new town-centre headquarters, combining the Cairo Street offices with a substantial Sankey Street store. His design featured full-length shop windows on the ground and first floors in delicate iron

Albert Warburton's original design for the Co-operative's town centre headquarters.

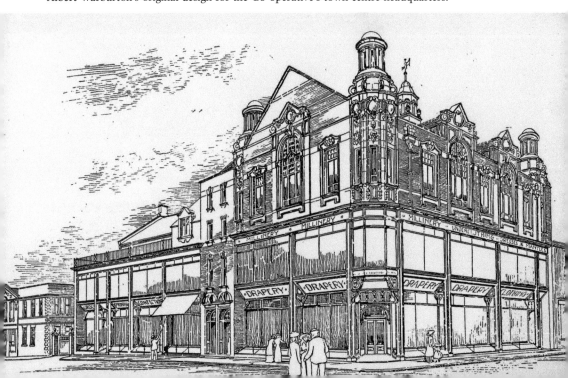

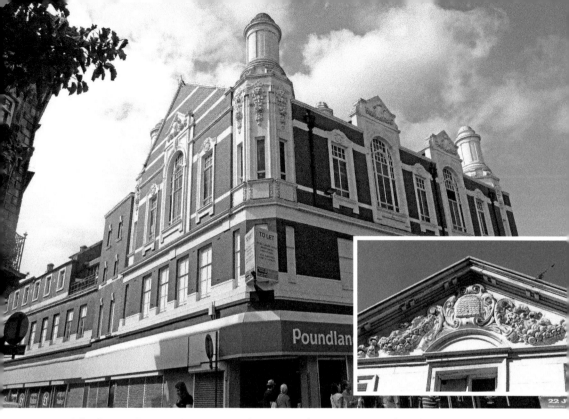

The former Co-operative store on the corner of Cairo Street and Sankey Street. *Inset*: The Co-operative Society's offices in Cairo Street were once a hive of activity.

frames and a hall, which could seat 700 people, on the top floor. On its completion in 1908, the *Warrington Guardian* proclaimed that it was:

> A block of shops equal to any in Warrington, such as would not disgrace the movement anywhere...arranged to accommodate Grocery and Provisions department, Boot and Shoes, draper, Clothing and Outfitting, Millinery, Mantles, Furniture, Crockery etc.

By the 1970s, the Co-op's fortune was in decline and the store closed, later trading again as T. J. Hughes, but Warburton's graceful facade had long since disappeared.

37. Warrington's Garden Suburbs

As in many industrial towns that had experienced a rapid growth in the second half of the nineteenth century, Warrington's workers found themselves crammed into insanitary courtyards off the main streets. Central government was reluctant to compel landlords to improve their properties but figures like Ebenezer Howard had a vision for garden suburbs, with more spacious housing than the crowded tenements. Arthur Bennett, a local accountant and politician, was a disciple of Howard's and had his own dream of a Warrington free from the pall of industrial smoke, where even the poor had good housing. In 1907, he set up the Warrington Garden Suburbs Company and planned extensive developments at Great Sankey and Grappenhall. In 1908, work began on four cottage-style dwellings on

Wright, Garnett & Wright's design for Sankey Garden suburbs on Liverpool Road.

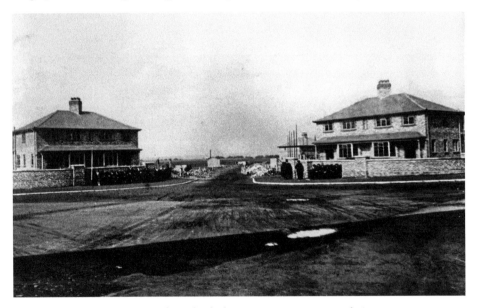

The Council's new Bewsey Garden suburbs housing estate nears completion.

Liverpool Road to designs by Wright, Garnett & Wright, which even included a bathroom as well as a parlour, dining room, kitchen, back kitchen, pantry and three bedrooms.

Bennett's ambitious scheme was never completed but as Chair of the Council's Housing Committee after the First World War, he was able to realise his dreams. The poor condition of working-class housing had become a concern during the war. A promise to build *Homes Fit For Heroes* was a key pledge of the 1918 Khaki Election and resulted in the 1919 Housing Act, which compelled local councils to build good houses and allowed them to

borrow money to achieve this. All the houses built with these loans had to follow strict guidelines to ensure that every builder would produce houses of the same size and quality. Warrington Borough Council began to buy up land to build new council housing estates, beginning on a smaller scale with houses off King Edward Street before undertaking the more ambitious Bewsey Garden suburb.

38. Warrington's War Memorial

After the First World War had ended, the people of Warrington wanted to pay tribute to those killed in action and especially those who were buried overseas. The idea of local memorials engraved with the names of the fallen was adopted to give communities a focus for their grief. Villages, churches and workplaces began to unveil their own memorials and in the Peace Celebrations of August 1919, a temporary cenotaph at Bridge Foot drew thousands of visitors. The site was chosen because, as the *Warrington Examiner* explained:

> At the junction of five leading thoroughfares in an open and central space where it was conveniently accessible from all parts of the town and conspicuous to those travelling through.

In 1921, Warrington Borough Council set up a war memorial committee to establish the town's permanent focus for remembrance. Disagreements about the site and the financial crisis caused by the post-war trade depression meant they delayed a decision until May 1924 when the proposals presented by borough surveyor Andrew Kerr were approved.

Warrington's cenotaph at Bridge Foot was unveiled in November 1925.

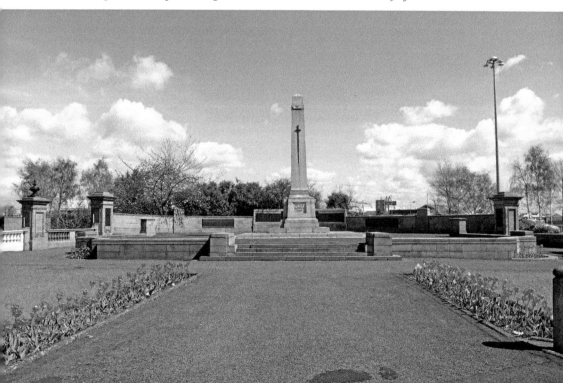

A site next to the new Warrington Bridge at Knutsford Road was chosen because of its historic importance and visible location but also because the council already owned the land. Kerr proposed to erect a granite obelisk because:

> this form of monument has, from the earliest known ages, been used as a memorial set up in honour of the gods and the great dead and by the addition of a cross on the front face, be made symbolic of Christianity, for the upholding of the principles of which, those who fell gave their lives.

The cenotaph was officially unveiled in November 1925 in the first of the town's annual ceremony of remembrance for those killed in the First World War and later conflicts.

39. The Masonic Hall

Warrington has a long history with Freemasonry and in 1646 Elias Ashmole recorded that he was initiated into the movement here. Warrington's oldest Masonic group, the Lodge of Lights No. 148, has been in existence since 1765 but until the 1930s Warrington's Masons had no permanent home, meeting instead in local inns.

On 22 September 1932, the foundation stone of their new temple in Winmarleigh Street was laid in the presence of Masonic dignitaries and prominent local businessmen. Its designer was local architect Albert Warburton, already well known as the architect of Crosfield's offices and the Sankey Street Co-operative store. His Masonic Hall was a

The Masonic Hall in Winmarleigh Street designed by Albert Warburton.

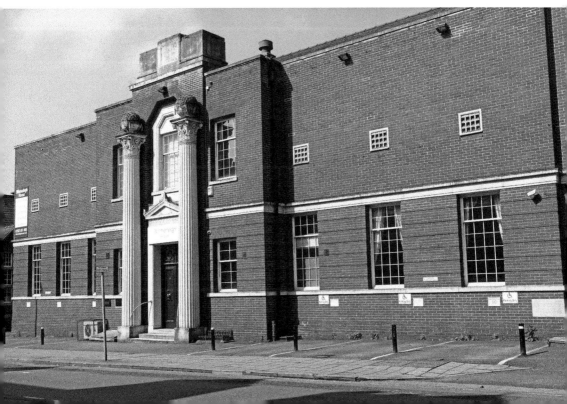

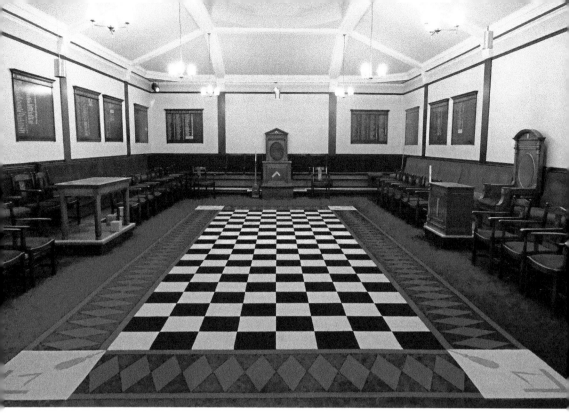

An interior view of the larger Masonic temple.

much plainer building, heavily influenced by the Egyptian and Greek motifs favoured by the contemporary art deco style. The simple brick facade has a striking stone entrance with two free-standing columns topped by net-covered globes, one terrestrial and the other celestial. The two columns represent the two pillars of Masonry, called Jachin and Boaz, which flanked the entrance to Solomon's temple. The stone decoration features biblical and Masonic symbolism, which would be clearly understood by all masons. Sadly, Warburton died before his final commission was complete.

Whereas the completed ground-floor function rooms are widely visited by the local community, the two imposing windowless temples on the first floor are normally reserved for members, apart from public guided tours. Around the walls are the names of the members of the various lodges, featuring many prominent local businessmen and politicians, including Sir Gilbert Greenall. The newly established Warrington Museum of Freemasonry now celebrates Masonic history in the town and its members' contribution to the local community.

40. K4 Telephone Box

Warrington's smallest listed building was conceived as an automated mini post office in the days long before mobile phones and emails. The K4 was created by the Post Office Engineering Department in 1930 and was based on the classic K2 telephone box designed by architect Sir Giles Gilbert Scott – a man better known for much larger buildings such as Battersea Power Station and Liverpool's Anglican cathedral. Warrington's K4 was installed

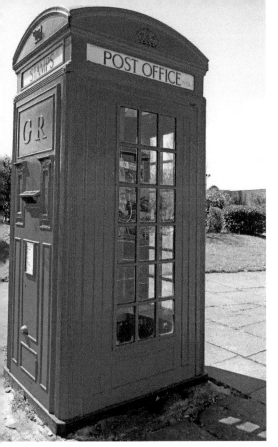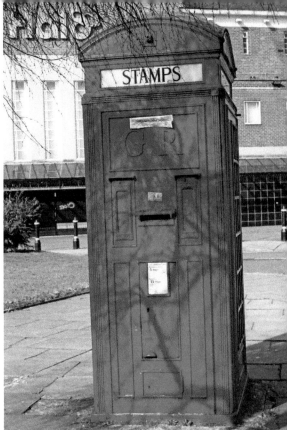

Above left: A view of the combined telephone box and stamp machine.

Above right: Warrington's K4 telephone box with Mr Smith's nightclub in the background.

at Bridge Foot outside the newly opened Ritz cinema, which would later become the iconic Mr Smith's nightclub. The K4 combined the functions of a public telephone box with a machine to issue stamps but unfortunately the concept proved flawed. Every time the stamp machine clanked into action, the person using the telephone was deafened. Only fifty of these 'Vermillion Giants' were ever installed as a result and Warrington's is one of only five surviving examples.

41. Fiddlers Ferry Power Station

Warrington's western skyline has been dominated by Fiddlers Ferry power station since it was commissioned in 1971. Dogged by planning disputes and industrial action, the 826-acre site took seven years to arise from the reclaimed marshes and farmland at Cuerdley on the border of Warrington and neighbouring St Helens. A fifteen-day public enquiry in 1963 saw local authorities, farmers, civic societies and environmental groups objecting to the potential atmospheric pollution from the site. The government dismissed these concerns on the grounds that the energy needs of the north-west were a greater priority.

Intended as Europe's biggest coal-fired electricity-generating plant, the station eventually cost over £90 million and had a projected life span of twenty five to thirty

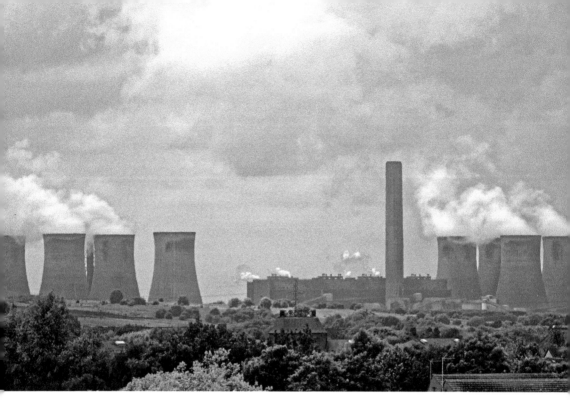

An iconic view of Fiddlers Ferry Power Station on Warrington's skyline. (Photo © Rob Gresty)

years. Construction work was hit by a series of costly strikes and five workmen lost their lives during the build. It was estimated that the plant would consume 4.25 million tons of coal annually and need 3 million gallons of water an hour pumped from the adjacent River Mersey. On completion, the massive 201.2-metre chimney was surrounded by eight 112.8-metre-high cooling towers, a boiler, turbine houses and other essential functions to create power for 2 million homes.

Built by the Central Electricity Generating Board the station had various operators until Scottish and Southern Energy (SSE) took over in 2004. By then, global environmental concerns and targets to reduce carbon dioxide emissions brought the future of coal-fired generators into question. Modifications intended to reduce sulphur dioxide emissions were introduced, extending the life of the site until potentially 2019. However, in January 2016 SSE announced it was considering shutting the loss-making plant sooner, with major implications for local employment and the already-stretched national supply network.

42. New Town House

The skyline of lower Buttermarket Street and Scotland Road is dominated by the bulk of a large office block in the uncompromisingly brutalist style from the 1970s. While its architecture may never have had populist appeal, the building's importance lies in its role in the development of present-day Warrington as the former headquarters of Warrington New Town Development Corporation (WNTDC).

In 1968, Warrington was officially designated as a new town, partly to redevelop the redundant Second World War sites of Risley munitions works and the former military bases

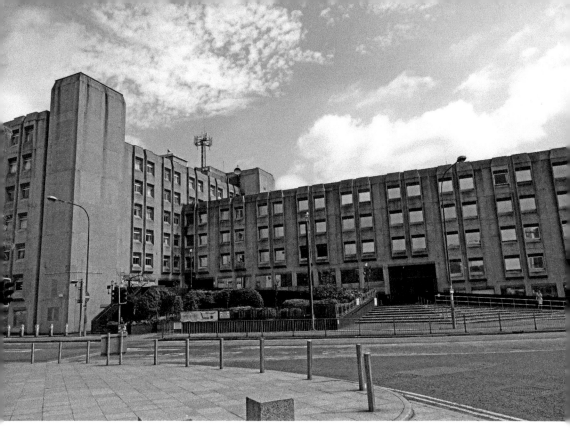

New Town House dominates Buttermarket Street and Scotland Road.

at Burtonwood and Padgate, and partly to become an overspill town for those relocated from Manchester and Liverpool. Warrington's transport links also gave it the potential to become a major regional growth centre with new retail, business and industrial hubs and a new local road network linked to the national motorway system. This was to be achieved by a master plan for the town whose population was expected to rise from 65,000 in 1965 to over 200,000 by the end of the century.

Work began in earnest in 1970, led by WNTDC rather than the existing Warrington Borough Council with the new organisation scattered in temporary accommodation across the town. In partnership with Norwich Union, WNTDC developed their headquarters on the site of Peter Stubs' former factory and the Britannia Inn on Scotland Road, leasing half the building on its completion in 1976. While its design may have been symbolic of a new age for the town, some conservationists were sceptical that architect Edmund Kirby had 'reflected the small scale of the existing town and avoided overshadowing the Georgian houses in the proposed Buttermarket Conservation Area, centred on St Mary's Church.' With the winding up of the Development Corporation in the late 1980s, Warrington Borough Council took on their tenancy of New Town House.

43. Golden Square

The regeneration of the Old Market area was the remit of Warrington Borough Council in partnership with developers rather than the New Town Development Corporation

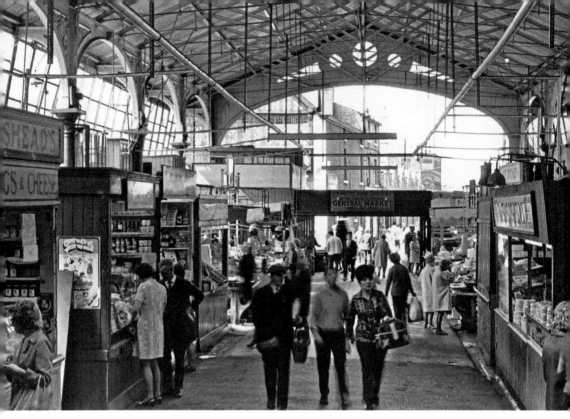

Above: Shopping for fish in the 1970s, or perhaps even cheese or tripe.

Below: Warrington's Old Market Place with the central canopy of the Fish Market. *Inset*: The *Mad Hatter's Tea Party* is installed in the Old Market Area.

and was linked to plans to remove traffic from the town's main shopping streets. Today's Golden Square shopping centre was created by construction work on an epic scale over three decades. The initial phase in the 1970s and 1980s, constructed by local builders A. Monk & Company, swept away all but the Barley Mow and the Old Fish Market, creating an open piazza with shopping malls and replica Victorian buildings. The second phase, built between 2004 and 2007, replaced the 1970s' bus station and Legh Street multistorey car park, creating a 365,000 square foot extension of prime retail space. The Old Market area was rebranded as Golden Square to create a more modern identity for the new retail centre. In fact, its 'new' name was taken from a historic map of the area, which referred to property owned by a Mr Goulden.

The focal point of Golden Square is the Old Fish Market. Originally an open shed adjoining a covered Market Hall, it was designed by Stevens as part of an earlier regeneration of the area in the mid-1850s. By the 1970s, the graceful structure was obscured by ugly side panelling, which protected traders and customers from the weather. Now restored to its former glory as the focal point of the Old Market Place, it houses a variety of entertainments and festivals instead of fishmongers, cheese stalls and tripe sellers. Nearby is the popular granite sculpture of the *Mad Hatter's Tea Party*, designed by Edwin Russell and featuring characters from local author Lewis Carroll's *Alice in Wonderland*. Commissioned by Legal & General, who had invested in the development of Golden Square, the statue was unveiled by Prince Charles and Princess Diana on 30 May 1984.

44. Cockhedge Centre

By the 1830s, Cockhedge had become Warrington's second major industrial area after Bank Quay, featuring a small glassworks, the extensive new works of Peter Stubs, a leading file manufacturer and a cotton mill. Although Warrington had one of the first steam-powered cotton mills in the north-west, it never became a major cotton-producing town. As a result of the cotton crisis of the 1860s, which had been caused by the American Civil War, most of Warrington's smaller mills went out of business and only Armitage & Rigby's Cockhedge works remained.

The mill survived a major fire in the 1870s and its spinning mill, weaving sheds and tall mill chimney dominated the adjacent terraced houses. By the post-war trade depression of the 1920s, almost one-fifth of the town's female workers were employed at the mill. Stubs relocated to a new site off Wilderspool Causeway in the 1930s, and by the 1950s Armitage & Rigby's operation began to fall into terminal decline as a result of cheap cotton imports.

In the 1980s, Warrington's town planners favoured relocating heavy industry away from the town centre while the retail sector was booming and looking for prime sites. Charterhall Properties stepped in to develop the new Cockhedge shopping centre, which opened in 1984. As the old mill was demolished, many of the cast-iron girders that had supported the roofs of the old weaving sheds were salvaged and given a new lease of life as an architectural feature of the new shopping arcade.

Above: Cockhedge Shopping Centre arcade with ironwork salvaged from the old mill.

Below: Inside the Cockhedge Mill weaving sheds in November 1918.

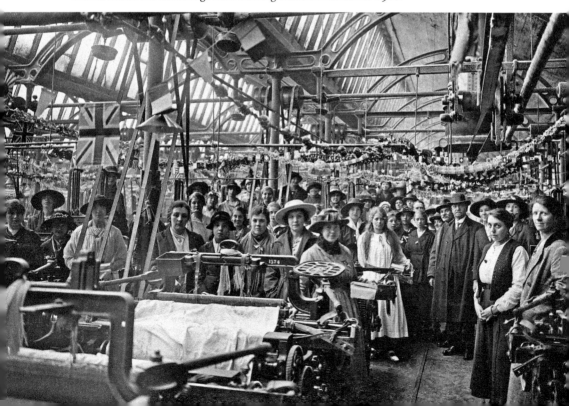

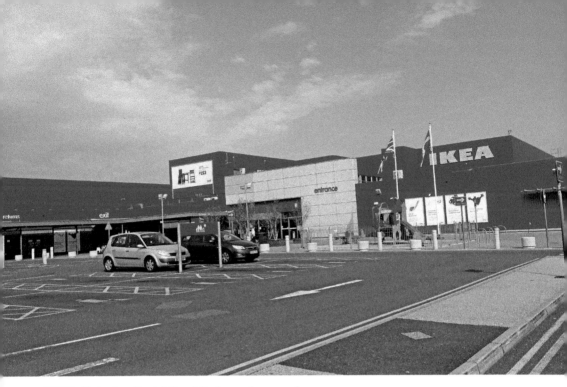

IKEA's distinctive Gemini Retail Park warehouse and store.

45. IKEA

On 1 October 1987, Swedish furniture giant IKEA opened its first UK store at Gemini Retail Park, making flat-pack furniture and meatballs a part of local culture. Warrington was chosen for their UK venture as it was one of the first towns in the country to build out-of-town retail parks, which were accessible to motorway links. By the time Warrington New Town Development Corporation's plan to redevelop the former American Second World War base at Burtonwood was launched in the mid-1970s, it was clear that the car was a crucial feature in daily life. The M62 motorway partly followed the line of the base's former runway and even though an adjacent motorway junction had yet to be built, IKEA Gemini soon became a regional tourist attraction. By a quirk of fate, the massive blue and gold steel warehouse not only symbolised Sweden's national colours but also the colours of Warrington's rugby league team and Warrington's former lords of the manor, the Botelers, whose coat of arms featured gold cups on a blue background.

46. The Peace Centre and the *River of Life*

The Peace Centre and the *River of Life* sculpture are two symbols of Warrington's response to an IRA terrorist attack in Bridge Street on 20 March 1993. Two bombs exploded without warning amongst the crowds of Saturday morning shoppers, killing three-year-old Johnathan Ball and twelve-year-old Tim Parry, and injuring many others. Warrington was determined that its response to the tragedy should be a positive contribution to the peaceful resolution of the conflict in Ireland.

Above: The Johnathan Ball & Tim Parry Peace Centre on Cromwell Avenue.

Below: The central water feature of the *River of Life* sculpture in Bridge Street.

Tim Parry (top) and Johnathan Ball (below) feature on the fountain's bowl.

The families of Tim Parry and Johnathan Ball worked with the NSPCC to establish a Foundation for Peace to work with young people and support those affected by terrorism and conflict. The charity's headquarters on Cromwell Avenue were designed by Graham Locke of Buttress Fuller Alsop Williams, who created a spacious building that blends into the landscape. Its dynamic pitched zinc-clad roof and weathered-timber walls create a substantial but not intimidating structure.

The *River of Life* sculpture in Bridge Street is a memorial to the events of 1993 and also a symbol of hope for future generations. Warrington's young people worked closely with sculptor Steven Broadbent to create the sculpture as an act of remembrance of two young lives cruelly cut short by the bombing. The *River of Life* is based on the geographical flow of the River Mersey as it travels through the borough. The design's overall theme and title came from the Bible and the Book of Revelations:

> Then the Angel showed me the river of the water of life, as clear as crystal, flowing from the throne of God and the Lamb down the middle of the great street of the city. On each side of the river stood the tree of life, bearing twelve crops of fruit, yielding its fruit every month. And the leaves of the tree are for the healing of the nations.

Set into the flow of the river, which is outlined by a darker-coloured edging, are twelve bronze plaques designed by twelve Warrington primary schools along the length of the River Mersey. Each plaque represents a month of the year and they are set out along the street to reflect the history of their locality along the Mersey, from the higher reaches at the east to nearer the mouth of the river to the west. Each plaque represents one of the trees of life with an actual leaf and a fruit and a simple inscription chosen by the children as symbolic fruits of 'Joy, Forgiveness, Love, Self-Control, Hope, Friendship, Faithfulness,

Peace, Encouragement, Reconciliation, Patience and Justice'. On 14 November 1996, HRH the Duchess of Kent cut a ribbon to formally start the *River of Life* flowing and unveil the redevelopment of Upper Bridge Street.

47. Pyramid

As Palmyra Square became the heart of Warrington's new Cultural Quarter, appropriate uses needed to be found to transform redundant locally listed public buildings in Palmyra Square South. In 1998, Heritage Lottery Funding was secured to create a performing arts centre in the century-old former county court and Inland Revenue building on the corner of Winmarleigh Street and the adjacent gymnasium of the former Technical School. Designed by Henry Tanner RIBA of HM Office of Works, the county court has a red-brick and yellow-terracotta facade with decorative moulding over the doorways, stepped gables on the roof, interior decorative glazed brickwork and stone staircases. While the former judge and registrar's courts on the second floor were lofty, well-lit spaces, many of the labyrinth of smaller offices presented a challenge to Studio BAAD, who were appointed to create suitable spaces for workshops and performances.

Their creative solution was to create a full-height new glass entrance hall that projected out onto the square without conflicting with the surrounding architecture; it also links the two buildings together. A larger glass extension to the rear also created new circulation, workshop and performance spaces that open off the central light-well, which has a contemporary industrial style. However, the restrictions of adapting a listed building limited conversion of much of the rooms in the old county court building. These have

The former County Court buildings in Wimarleigh Street in the early 1900s.

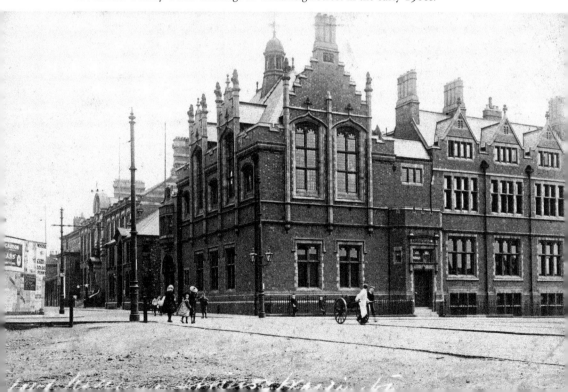

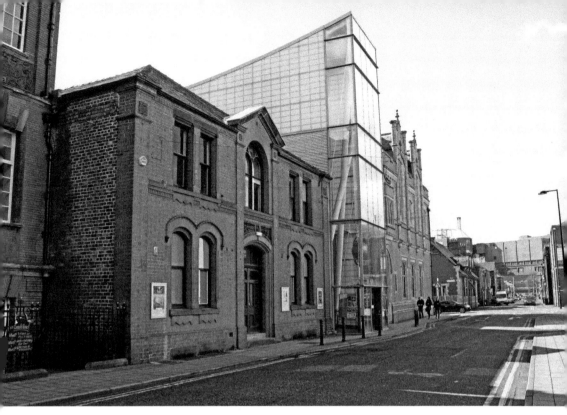

The three structures making up the Pyramid Art Centre in Palmyra Square.

been retained as office accommodation for Culture Warrington, a charitable trust, which has operated the building for Warrington Borough Council since May 2012, providing arts, heritage and events for the town. Pyramid opened in 2002, adding another Egyptian-themed venue to Palmyra Square.

48. The Guardians

With the creation of the new Golden Square shopping complex in the 1980s, the town centre's original focus at Market Gate seemed neglected. Pedestrianisation of the four main streets by the 1990s left a variety of unattractive street surfaces and ugly concrete flower troughs, which compared unfavourably with the *River of Life* feature in Bridge Street. Warrington Borough Council boldly decided to use a £3.4 million public art scheme to enhance the townscape with funding from the Arts Council and windfall money received from Cheshire County Council. Leading American artist Howard Ben Tré was chosen from a shortlist of distinguished artists to transform Market Gate, Buttermarket and Horsemarket Streets with a more limited intervention in Sankey Street. Ben Tré was influenced by the architecture of the existing streetscapes as well as the town's industrial heritage of glass and copper working and the design for a figurative sculpture championed by Arthur Bennett a century earlier.

Central to Ben Tré's scheme is the Well of Light at Market Gate, surrounded by ten abstract columns representing those who guard Warrington's heritage in the past, present and future. The ten bronze Guardians have a copper-effect surface and are topped with

An earlier proposal for a figurative sculpture that helped inspire the Guardians.

glass capitals. Each weighing 300 kilograms, the glass capitals were designed by Schott Glass technologies of Pennsylvania. A series of gardens were planted in Buttermarket and Horsemarket Street between the granite seating and other structures and 206 water jets form a dancing sculpture in Horsemarket Street.

The scheme was carried out between 2000 and 2002 and was met with a mixed public reaction. Gradually, the planting has softened the hard landscaping and the Guardians have been given the semi-affectionate local nickname of 'The Skittles'. The scheme also won the accolade of the Royal Town Planning Institute North-West 'Best Urban Design Project'.

49. Warrington Wolves stadium

For many Warringtonians, the town's most important building is the rugby league stadium, which is central to their cultural heritage. Formed in 1876, Warrington's club became one of the founders of the Northern Rugby Football Union in 1895 and helped make the breakaway from rugby union to rugby league football. Until the advent of the Super League in 1996, the team were known as 'The Wire' – a nickname derived from the 'wirepullers' who were the elite workers in Warrington's major wire industry. The decline of wire-working and the demands of televised rugby led to the club rebranding itself as Warrington Wolves. The new team was also in need of a new stadium as its Wilderspool ground no longer met the needs of a modern club.

The rugby league club's former home at Wilderspool Stadium.

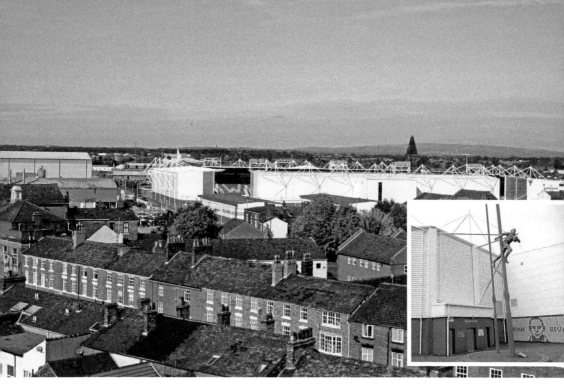

Warrington Wolves stadium is a distinctive new addition to Warrington's northern skyline.

In 2001, planning permission was finally given for a new stadium to be built alongside a Tesco superstore on the site of the redundant Carlsburg-Tetley Brewery. Work started on site in December 2002. The following September, the north-west motor group Halliwell Jones were announced as the club's major sponsor. Unusually, the new ground included terraces as well as seating areas and its dimensions ensured that major fixtures could be staged. On 21 February 2004, the first scheduled match was televised live as Warrington Wolves defeated Wakefield Trinity Wildcats in the opening round of Super League IX. In 2012, ground capacity was increased to 15,200 and the following year the Halliwell Jones Stadium was the venue for two Rugby League World Cup fixtures.

Two monuments to Brian Bevan, Warrington's legendary Australian winger (1948–62), are a prominent reminder of the club's heritage at the stadium entrance. The statue of Bevan in action was relocated from its original Wilderspool site and a new portrait of him in inscribed bricks in the club's famous blue and yellow colours was installed nearby.

5c. Orford Jubilee Park

One of Warrington's newest buildings was given the royal seal of approval when Elizabeth II opened Orford Jubilee Park on 17 May 2012 during her Diamond Jubilee tour of the country. This iconic facility is the only legacy of the 2012 Olympics outside of London but it was designed to be more than a sustainable community sports hub. The project was the culmination of lengthy local planning to develop a 'one-stop shop' that combined a leisure centre with a co-located library and primary health care, offering a GP centre and pharmacy.

The distinctive chequerboard facade of Orford Jubilee Neighbourhood Hub.
Below: Elizabeth II at the opening of the hub in May 2012.

Designed by Rocco Ralman Architects and built by Galliford Try Construction, the
multimillion-pound scheme was funded by over twenty national, regional and local sources
from the public, private and voluntary sectors. Originally commissioned by Warrington
Borough Council. the venue is now operated by LiveWire, a new community interest company
(CIC), established in May 2012 to provide leisure, libraries and lifestyle facilities for the town.
Warrington's legacy project swiftly increased participation in leisure activities and improved
wellbeing. The building has successfully combined form with function and laid the foundation
for the next generation of Warrington's pioneering neighbourhood hubs.

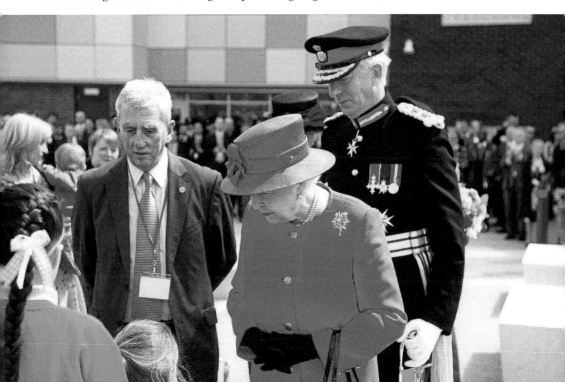

Acknowledgements

This work would not have been possible without the work of all those who have documented the history of Warrington's buildings over the centuries and particularly to the Culture Warrington staff who care for the town's local studies and archives at Warrington Museum. Every effort has been taken to trace the copyright holders of the images in those collections and thanks are also due to those who have photographed the town for future generations to appreciate its history. Especial thanks to Rob Gresty for his contemporary images, as indicated in this volume. Finally, acknowledgements to all the architects who have created Warrington's built environment and to those who ensure it is safeguarded.

By 2018 there will be three fewer Warrington buildings – a consequence of the regeneration of Bridge Street. Whether the Market Car Park (left,) the blue link-bridge over Academy Way or the Market Hall (right) will be mourned as Warrington's lost heritage is for history to decide.

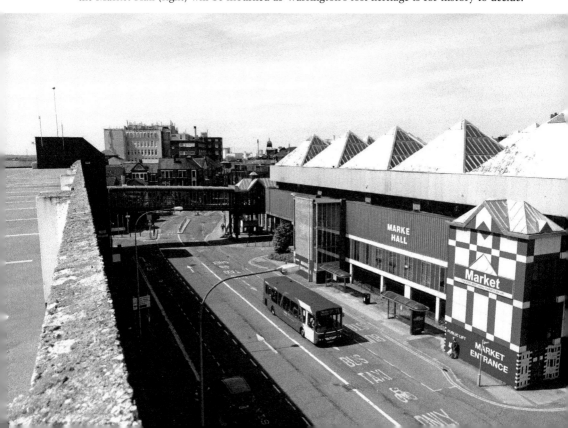